Strandhill

An Illustrated History

First published by Eastwood Books, 2019

Dublin, Ireland

www.eastwoodbooks.com
www.wordwellbooks.com
@eastwoodbooks

First Edition

Eastwood Books is an imprint of The Wordwell Group

Eastwood Books
The Wordwell Group
Unit 9, 78 Furze Road
Sandyford
Dublin, Ireland

© Peigín Doyle, 2019

ISBN: 978-1-9161375-4-7

British Library Cataloguing in Publication Data.
A catalogue record for this book is available from the British Library.

Strandhill

An Illustrated History

Peigín Doyle

Eastwood

Contents

Acknowledgements

This book is dedicated to the people of Strandhill, whose generosity in sharing their family and organisations' photographs has made it possible.

The ownership of each image has been credited in the book. However, I would like to thank personally: Stefan Bergh; Donald and Joan Bree; Stan Burns; Patsy and Dorothy Byrne, and the Byrne family; John Coleman; Joe Corcoran, Sligo Regional Airport; Sandra Corcoran, Strandhill Golf Club; Kathleen Devins *née* Mannion and the Devins family; Brid Dolan; Deirdre Foley; Andy Higgins; Strandhill Guild Irish Countrywomen's Association; Bobby and Alice Jones; Roy Kilfeather; Zoe Lally, the Irish Surfing Association; Hugh MacConville; Sean and Alice Mannion; Nick Maxwell; Ita McMorrow-Leyden; Geraldine Murrow; Marion Neary; Fr Frank O'Beirne; Dr John O'Donnell; Scoil Asicus Naofa and Ms Anne Ruane; Sligo County Council Infrastructural Services Section; St Anne's parish, and Richard Wood Martin for the kindness they showed me in sharing their photographs.

I am very grateful also to Fr Niall Ahern; Dolores Byrne and Sean Byrne (deceased); Brid Carew; John and Kathleen Duggan; Ursula Gilhawly; Vivienne Henry; Orfhlaith and Robin Hurley; Walter Irwin; the Irish Architectural Archive; Eamon Joyce (deceased), formerly of The Neptune Stores; Office of the Diocese of Elphin staff; Michael Keane; Shane Kennedy; Cormac MacConville; Dermot MacConville; Joe McDonagh; Annie-Joe Mannion; Michael Murray; National Library of Ireland Photographic Archive staff; Bridget O'Dowd; June Parke; Sligo County Museum and Angela McGurrin; Sligo County Reference Library; Tiger Print; Revd Arfon Williams, and Mark Wehrly for their courtesy and help.

I am grateful to the British Library Board for permission to use William Larkin's 1819 Map of the County of Sligo in the Province of Connaught in Ireland.

I wish to thank the Irish Military Archives, Cathal Brugha Barracks, Dublin, for making available the photographs of the Irish Air Corps aerial survey of Strandhill and Sligo.

A special tribute is owed to John McTernan, historian and author, who documented the history of Strandhill in *At the Foot of Knocknarea: A chronicle of Coolera* in bygone days and other publications.

Some historical information that I drew on was given to me by Denis Mannion and Bob Murrow, now deceased.

I am indebted to Ronan Colgan, formerly of The History Press and currently of Wordwell Books, who first suggested that the story of Strandhill should be told through old photographs.

I owe special thanks to my family for the interest and support they gave me.

Foreword

When I first started to carry our research for this book, it seemed as if it might never succeed. In the early days, cameras were rare and expensive, and few people took photographs. The national and local archives had no more than forty or fifty images of Strandhill – not enough to fill a book.

Then I hit on an idea: if I asked people whose families had lived here for generations to show me their photographs, maybe this would help me tell what life in Strandhill was like in times gone by. Their generosity in showing me their photographs and allowing me to share them with you has made this book possible. I am grateful to them all.

In Strandhill in the late nineteenth century, a number of seaweed bathhouses at Larass and Culleenamore townlands offered visitors the health benefits of seaweed baths. At that time, Strandhill was centred around Larass townland, with some scattered clusters of houses in adjoining townlands and a number of landlords' large houses.

Strandhill began to be developed as a seaside resort from around the 1900s. Benjamin Murrow built the exotically named Buenos Ayres Drive and opened seaweed baths at the seafront, close to the cannon he had placed there. Many of today's private homes and pubs started out as lodgings for the visitors who came from rural parts of Sligo and Leitrim. Families from Sligo town often used to camp the whole summer on the sand dunes for their holidays, or later in caravans in the caravan park.

When my husband and I first came to Strandhill in 1979, we rented a flat in The Wolfhound, formerly The Waverley Hotel. True to its name, one of the occupants was a wolfhound that used to sprawl at the bottom of the stairs, and you could trip over him on your way down to the bathroom if you were not careful.

In 1979 it was still quite a small village, with open fields and sand dunes between scattered houses. It had a sandy beach where you could swim and jump in the waves. The tourist season was short, lasting no more than four to six weeks if the weather was good. If you wanted to buy food or Sunday newspapers, you had to drive in to Sligo, though you could get your bread and milk at Mrs Barry's shop at the seafront, or Hanna Mannion's shop in the two-storey house where the Sligo road splits into the Top Road and the Burma Road.

In the off-season, when the visitors were gone, accommodation could be had relatively cheaply. Musicians, craftspeople, students and people with interesting backstories found their way to Strandhill and made their homes there. Saturday night music in a local pub, with any of the large number of musicians that lived or played there, might unexpectedly take off and become a legendary session. Kevin

Flynn brought memorable music groups to play in The Venue, once called Coles. The Jazz Ladds played trad jazz there every Saturday night for years. The Baymount and The Silver Slipper ballroom were each a mecca for dancers and music fans from far and wide.

Denis Mannion, who was to become a firm friend, was the first person to tell me snippets about Strandhill in times gone by: about gathering seaweed for fertiliser with his father and grandfather, and taking it home by cart across the green banks at Culleenamore beach; of the old Ballisodare to Sligo road that ran along those banks and over the sand dunes to Rinn and on to Sligo; about gathering multicoloured shells from the beach to spread on the ground below the thatch of the family house, where they would stop the raindrops from bouncing up and dirtying the whitewashed walls; of shebeens and landlords and yarns about old characters.

Sonny Bree, who owned The Strandhill Bar with his sister Bridie, was another source of memories and many nights he, Denis and Aodhan O'Higgins, another great local historian, would spend hours discussing some incident long ago. I owe them special thanks.

Former Sligo county librarian and historian John McTernan gathered all the documentary references to Strandhill over the centuries and recorded its history from earliest times in his book *At the Foot of Knocknarea: A chronicle of Coolera in bygone days*. This book does not aim to replace or update these histories but tries to bring them to life by showing who the people were, and how they dressed, worked and lived.

Strandhill has changed and developed, as vibrant places do. In the late 1960s, it was discovered that Strandhill beach was excellent for surfing, and surfers came to ride the waves, then stayed. In time, some set up surf schools.

Local volunteers organised the first Warriors Run in June 1985. Rain and an overcast sky could not dampen people's enthusiasm as they watched the 160 runners race from the seafront to Queen Maeve's tomb on the summit of Knocknarea. Today, one thousand competitors take part, running or walking to the legendary grave and back to the seafront. The same voluntary community spirit was responsible for reviving the centuries-old tradition of horse racing on Culleenamore beach.

Strandhill's people made it the place it was and is. I hope this book will help to keep their spirit and memories alive into the future.

Peigín Doyle

1.
Ancient Strandhill

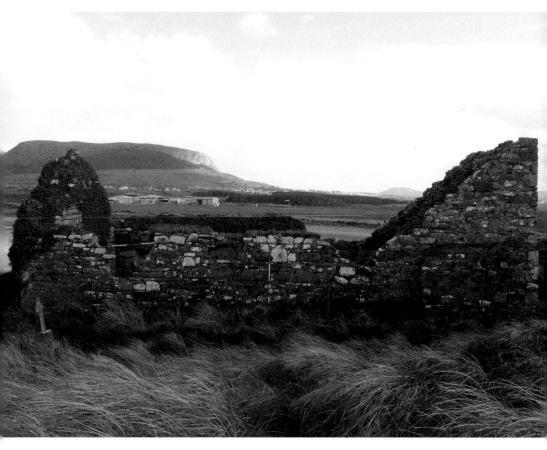

It is said that St Patrick marked out the site for an early Christian church at Killaspugbrone. There may have been an older circular stone enclosure, or caiseal, on the site already. Within it, his disciple Brónus built his church, which became known as Cill Easpaig Brón – 'the church of Bishop Brón'. Annals said Brónus died in AD 511 and that his memory was honoured in the locality on 8 June. Killaspugbrone was once home to the relic known as Fiacal Padraig, or St Patrick's Tooth Shrine, which is now in the National Museum. The present church dates from the eleventh or twelfth century, and was mentioned in Papal records in the early fifteenth century. *(Photograph kindly made available by Hugh MacConville.)*

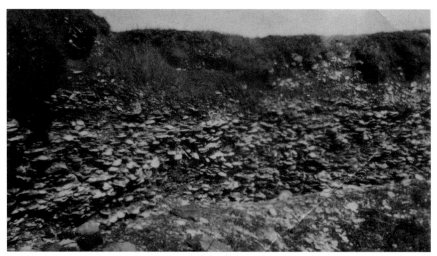

The shell midden at the Sandy Field, Culleenamore, taken in the early twentieth century. From the Middle Stone Age to the medieval period, people used to eat shellfish and leave the shells behind them in heaps, or middens. This went on over several generations or hundreds of years, forming large mounds. Such outdoor meals may have taken place as social gatherings by early Stone Age people who met a few times a year to arrange marriages or burials, or to share resources. The midden at Culleenamore stretches for over 100m and is about 1m high, which would have taken a long time to build up. *(Photograph part of the Nuttall collection and kindly made available by the Mannion family.)*

The 'Giant's Grave' sits on the eastern side of the Airport Road in Killaspugbrone townland. It is a court tomb, probably the earliest type of funeral monument built by Ireland's first farming people. The skill needed to move and raise such huge stones suggests a settled, well-organised community with time and labour to spare. Court tombs usually have an uncovered courtyard in front of a covered burial vault, which is divided by boulders into a number of separate chambers. The human remains tend to have been cremated. This tomb is built from seven large limestone boulders and is divided into two chambers. The court may be hidden in the grass or buried.

This steep mound is located on the lower slopes of Knocknarea beside the modern St Asicus National School on the golf links road. It is circular and about 25m on its outside banks. When it was built it would have had views in all directions, including Killaspugbrone, the seashore where food would have been available from fishing, and another ringfort or barrow that sits on the boundary of Carrowbunnaun and Carnadough townlands. It was described in the 1913 Ordnance Survey as an 'enclosure', but it may be a platform ring-fort with a raised central area. Ringforts are circular enclosures, usually farmsteads, and were mainly built between AD 600 and AD 900.

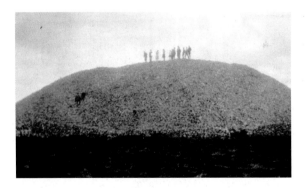

A group of people stand on Maeve's Cairn on Knocknarea, some time in the 1920s. Maeve's Cairn, or Miosgáin Méadhbha, on the summit of Knocknarea, is a Neolithic passage grave, which is a focal point for the entire ritual landscape of the Coolera peninsula, in which Strand hill is located. The image comes from the collection of Freeman Aeneas Nuttall, who resided on what was once the estate of the Barrett landlord family at Culleenamore townland. He ran a successful market garden business there, following his return to Strandhill from Canada in 1921. We know now that standing on Maeve's Cairn damages the monument, and could even cause its collapse. (*Photograph part of the Nuttall collection and kindly made available by the Mannion family.*)

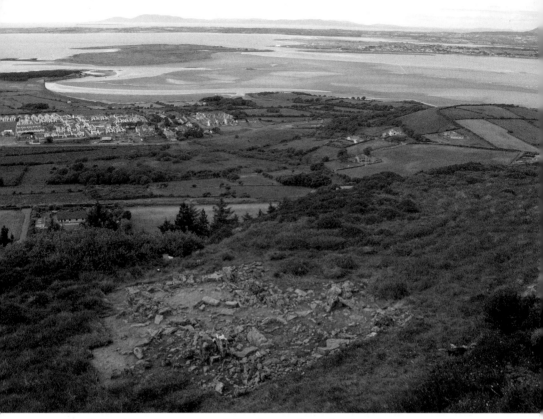

Strandhill and Sligo Bay stretch out below this site of an archaeological excavation made in 2010 on the slopes of Knocknarea. The excavations revealed the stone foundations of four rectangular houses of probably medieval date. No datable artefacts were found, and why people were building houses on this exposed and very limited ledge overlooking the Atlantic remains a puzzle. In the left side background can be seen part of Sligo Regional Airport, and beyond that the headland on which sits Killaspugbrone church and graveyard. *(Photograph kindly made available by Stefan Bergh.)*

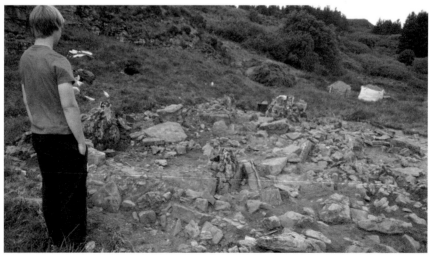

A closer view of the excavated site on Knocknarea, showing the large stones used in the foundations for one of the houses. *(Photograph kindly made available by Stefan Bergh.)*

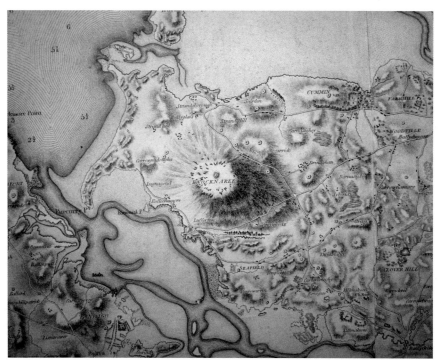

In the early nineteenth century, the Sligo Grand Jury, the forerunner of the modern County Council, asked the surveyor and engineer William Larkin to draw a map of County Sligo. It was completed and published in 1819. It shows the landscape and the various hamlets that grew into the modern Strandhill as they were twenty-six years before the Great Famine. Shaded circles indicate the passage tomb on Knocknarea and many ringforts. A lost hamlet, Ballyglass, is shown, as well as a cluster of houses on the shore near Strandborough, which was probably the original village of Strandhill before it was buried by blowing sands. The present main road (R292) was not built and the place name Lugnagonel, at the shore of Culleenamore beach, does not appear on any other map. (© *British Library Board. The British Library; System No. 004933760; Maps 13430. (4).*)

2.
Seaside Days

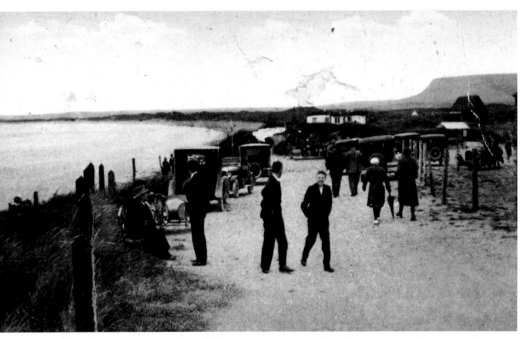

This early Milton postcard, originally tinted, shows the seafront from the south, facing towards Benbulben mountain. Wooden posts separate the unpaved, sandy path from the beach, and, in the background, people are seated around the plinth of the cannon. The dark rectangle visible against Benbulben was a shop onto which was later added a shop called the Beach Stores. The cars may be early Ford designs from the middle to late 1920s or early 1930s. Milton postcard views of Ireland, Britain and Europe, were published by the Woolstone Brothers, London, between 1902 and 1933. (*Postcard kindly made available by the Mannion family.*)

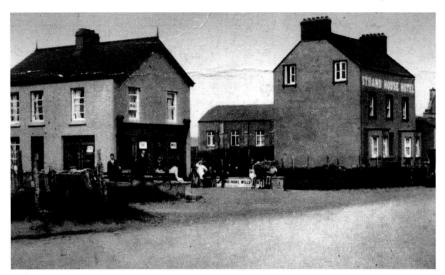

This Milton postcard, originally tinted, shows the road near the seafront with the Strand House Hotel (right, built in 1913) and George Parke's shop (left), which opened around 1928. Between the two buildings is the Plaza Ballroom and Café, which opened in 1929. Just past the Strand Hotel is a timber house occupied at one time by the Mulrooney family, and past that is the two-storey wall of the Star of the Sea hotel. A space between these two buildings became the entrance road to the caravan park in the early 1960s. The Strand House Hotel was owned by a number of people during the twentieth century, until it was acquired by Patsy Byrne in 1982 and developed into the Strand Bar. (*Postcard kindly made available by the Mannion family.*)

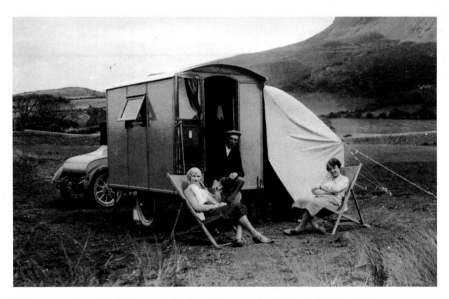

Visitors camping with their mustard-coloured caravan in the Sandy Field at Culleenamore, some time in the 1930s. They are probably members of the Johnston family who owned Alan Johnston's shoe shop on Wine Street, Sligo, now gone. (*Photograph part of the Nuttall collection and kindly made available by the Mannion family.*)

FOR HEALTH
AND
PLEASURE
Visit the
SLIGO COAST
THIS YEAR !

An ideal spot for interesting Holidays. Richly stored with antiquarian interest. Strandhill, with its beautiful bay, silver sand, affording excellent Bathing. Bracing air.

GOLF
can be had on one of the finest courses in Ireland—
ROSSES POINT
(18 holes) and ample facilities for Boating, Sea & River Fishing.
SEE LOUGH GILL (The Killarney of the West).
Excellent accommodation in the
GREAT SOUTHERN HOTEL, SLIGO.

Illustrated Booklets and particulars of Cheap Fares supplied free on application to any Tourist Agency or to
P. J. FLOYD,
KINGSBRIDGE, DUBLIN

An early tourism advertisement by Great Southern Railways (GSR), promoting the 'Sligo Coast', including Strandhill, with its 'silver sand' and 'excellent bathing'. The Great Southern Railway Company owned and operated all Irish Free State railways between 1925 and 1945. It also acquired and ran a number of hotels under the name Great Southern Hotels until 1990. The Great Southern Hotel in Sligo is the only hotel that still uses the original name. The advertisement was published some time before 1945, when GSR became part of Córas Iompair Éireann (CIÉ).

This is another postcard from the Milton series, again originally tinted, which shows the seafront from the north facing towards the seaweed baths and the Ox Mountains. The roof of the bathhouse can be seen clearly. Commercially printed postcards broke an early monopoly of producing cards held by the Post Office. They could not print the royal arms on the reverse, and so some postcard publishers printed their own symbol. The Woolstone Brothers printed a woman's head as a Milton trademark on the reverse of their cards. (*Postcard kindly made available by Andy Higgins.*)

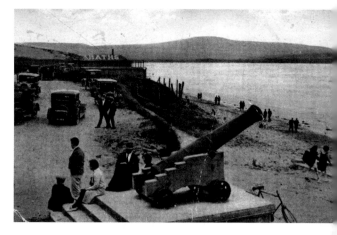

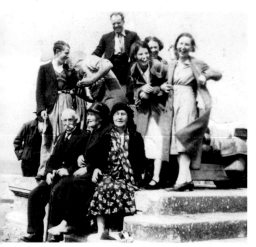

When Maisie McGovern, *née* Benson, was a schoolgirl in the Ursuline Convent, Sligo, in the 1930s, she was given a present of a Brownie camera. With the camera, she recorded family outings and events in the 1930s. Here, the Benson family and friends, who lived in Ballymote, are seen at the cannon on the seafront on a trip to Strandhill in 1933 or 1934. The girl on the right is Maisie's sister Kathleen, and to her left, Sheelagh Johnston. Second row left is Johnny Benson, Maisie's brother, who later was a teacher in the vocational school in Sligo and wrote a weekly 'Sligo GAA' digest in *The Sligo Champion* for many years. The laughter and good humour on show in this picture reflect the fact that life in the 1930s, although the country was poor and undeveloped, could be just as much fun as it is today. (*Photograph part of the Maisie Benson McGovern collection courtesy of John Coleman.*)

Maisie Benson took this photograph of a group of excursionists at the cannon in Strandhill in 1933 or 1934. For people at the time, it was a significant event to go on an excursion to Strandhill from places like Ballymote. (*Photograph part of the Maisie Benson McGovern collection courtesy of John Coleman.*)

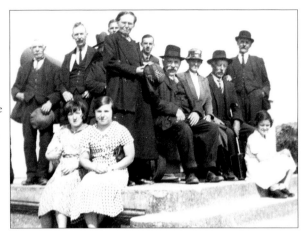

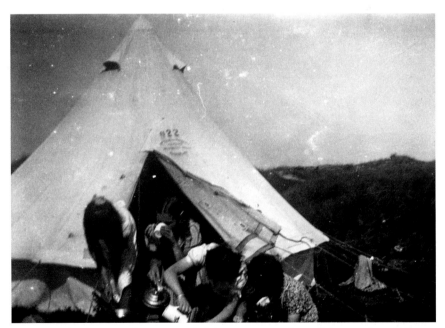

Many Sligo families spent their summer holiday camping on the sand dunes in Strandhill. The Benson family stayed in a boarding house but there was always great excitement among the younger family members when the Boy Scouts from Cavan were camping in Strandhill. The Benson girls have made tea and are about to fry up some food at the scout tent. The girl holding the cup is Sheelagh Johnston. The large bell tent was made of canvas, which, in wet weather, could leak if someone inside brushed against it, requiring careful movement to avoid drips. The guy ropes were often used as a drying rack for swimming togs and towels. (*Photograph part of the Maisie Benson McGovern collection courtesy of John Coleman.*)

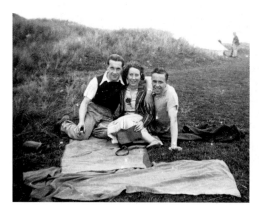 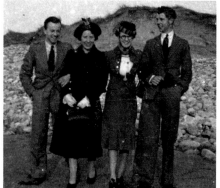

LEFT: This is a later photograph showing Maisie Benson as a young woman, together with friends, on the dunes at Strandhill. A tent can be seen in the background. Maisie was born in 1917, so the photograph was taken some time around 1937. (*Photograph part of the Maisie Benson McGovern collection courtesy of John Coleman.*)

RIGHT: Dressed in their finery, Maisie Benson (second left) and her friend Terry Regan (second right) and friends, take a walk on Strandhill beach in the late 1930s. Despite the Great Depression, women's clothes could be glamorous, and a narrow-skirted suit with kick pleats, and a pillbox-style hat, as Terry Regan is wearing, were all the style. At that time, people often had their clothes made by a local dressmaker. They might see a photograph of a dress in a newspaper and have it made up for them very quickly. Ballymote had a very good dressmaker at the time. (*Photograph part of the Maisie Benson McGovern collection courtesy of John Coleman.*)

OPPOSITE BELOW: The seafront and cannon as they were in the early 1960s. A raised platform with seating overlooks the sea where there is now rock armour and (mid-background, right) a low wall separates the seating area from the northern end of the beach. The wall was built by Andy Kearney of Beltra. Later, a slipway that gave access to the sea, with a higher wall, was built at this spot, but it was closed in the early 2000s, blocked by rock armour and replaced by the slipway at the southern end of the seafront. (*Photograph kindly made available by the Byrne family.*)

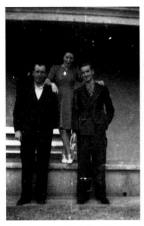
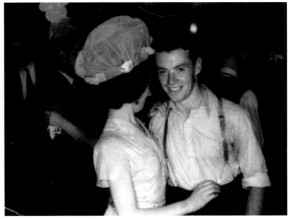

ABOVE LEFT: Kathleen Benson, sister of Maisie Benson, and two friends outside the Central Hotel (later called the Sancta Maria) in the mid-1940s. The Central, originally the Atlantic Hotel, was probably owned at that time by George W. Monson and his sister Rose, who grew up in High Street, Sligo. *(Photograph part of the Maisie Benson McGovern collection courtesy of John Coleman.)*

ABOVE RIGHT: Shown dancing in the Plaza Ballroom in the 1950s are Kathleen Devins (*née* Mannion of Carnadough), in fancy dress hat, and Paddy Fallon. The Plaza Ballroom and Café was located beside the Strand Hotel near the seafront and advertised itself as the 'most up-do-date ballroom in Connaught'. The Plaza Ballroom opened in 1929 and as well as a venue for dancing, it operated for a time as a skating rink. It closed in 1960, when the Silver Slipper opened, and it was knocked down in 2002. *(Photograph kindly made available by the Mannion family.)*

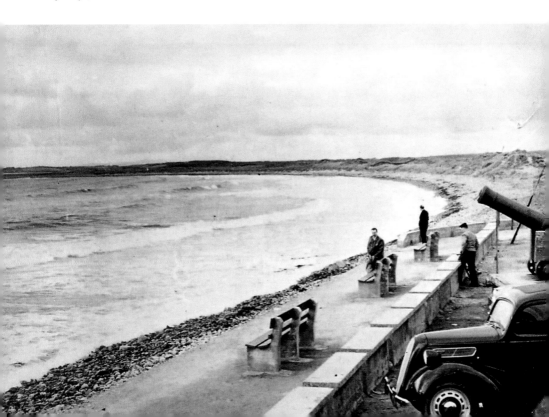

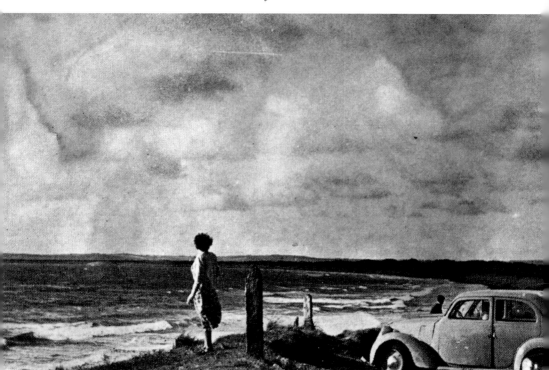

The lady in this picture, taken some time in the late 1950s or early 1960s, is standing at the northern end of the seafront looking across Sligo Bay towards Lissadell. (*Photograph kindly made available by the Byrne family.*)

This Cardall postcard of the seafront, printed in the late 1960s or early 1970s, shows the seating has gone. The ladies' hemlines are also shorter, but one thing has not changed – children climbing on the cannon (top right). Something new can be seen in the middle background on the beach – someone is carrying a small bodyboard, showing that surfing is becoming popular as a sport and a seaside pastime. The white building just behind the cannon may have been the beach guard hut, which was installed every summer. (*Postcard kindly made available by the Mannion family.*)

A John Hinde postcard of Strandhill beach facing towards the Ox Mountains. Judging by the man's denim jeans and the woman's dress, the photograph was taken in the late 1960s or early 1970s, as the postcard business in sold in 1972. John Hinde, who said once in an interview that his highly coloured postcards were 'an attempt to visualise Heaven', used vibrant colours, dramatic scenery and stereotypical Irish images to entrance the viewer. A note on the reverse of the postcard praised the 'fair fishing and rough shooting in the neighbourhood', and 'the excellent facility for dancing in the modern ballroom'. People used to shoot pheasants and they were reared for many years in a field in Rinn townland. (*Photograph kindly made available by Andy Higgins.*)

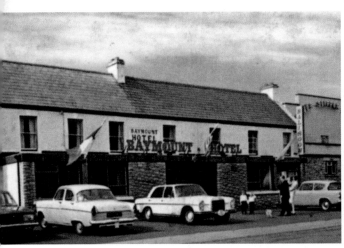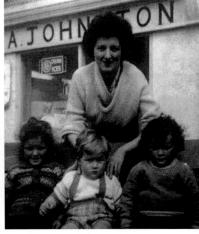

ABOVE LEFT: The Baymount Hotel and the Silver Slipper ballroom, owned by Sean Byrne, were hugely popular among visitors and Sligo people alike. People travelled miles to listen and dance to world-class musicians and showbands, including stars like Bill Haley, Roy Orbison and Engelbert Humperdinck. Many well-known Sligo musicians performed there regularly. The Baymount Hotel was built by John (Jack) Byrne in the 1920s, and his son Sean built the Silver Slipper in 1960. (*Photograph kindly made available by Roy Kilfeather.*) ABOVE RIGHT: The seaside and the summer spell ice cream, and Johnston's shop at the seafront (formerly the Paragon Stores), run by the Johnston family, was a popular place to buy cream ices. Dorothy Byrne (*née* Johnston) is photographed here outside the family shop with (left to right) Shirley, John and Jacqueline Byrne. (*Photograph kindly made available by Roy Kilfeather.*)

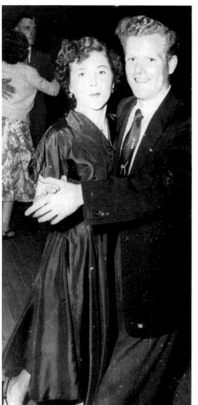

Dancing in the Silver Slipper in the 1960s were Evelyn Murray and Packie Foley, from The Bridge, Larass. The Silver Slipper finally closed in 1989 and was demolished in 1992. Apartments now occupy the site. (*Photograph kindly made available by Andy Higgins.*)

BELOW: Many social events were held in the Baymount and the Silver Slipper, including this Post Office dinner dance in 1960. Among the throng, in the front row, fourth left, is Lily Duignan, wife of Edward Neary, Sligo town, aunt of the owner, Marion Neary. Sean Byrne can be seen wearing evening dress beneath the spotlight on the left of the stage. Staff of the Silver Slipper wore a uniform of grey trousers, light blue jacket, white shirt and maroon dickie bow. (*Photograph kindly made available by Marion Neary.*)

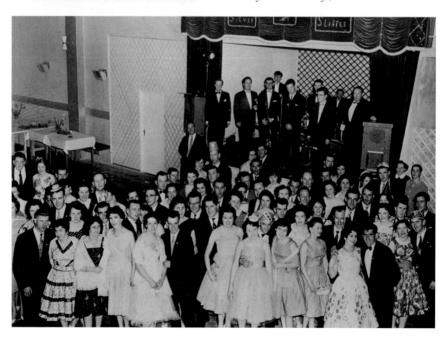

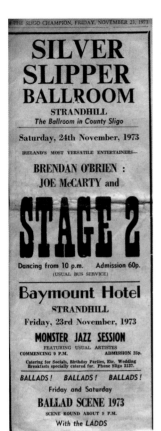

This advertisement appeared in *The Sligo Champion*, announcing a Monster Jazz Session in the Silver Slipper on Friday, 23 November 1973. On Saturday 24 November, there was dancing to top showband stars Brendan O'Brien and Joe McCarthy. They played originally with The Dixies and in the early 1970s they formed Stage 2, which is the name of the Silver Slipper act. Admission to Stage 2 was 60p, and 25p to the jazz session. In the old decimal Irish currency, there was 100p in the pound, called the punt. When Ireland converted to the euro in 1999, IR£0.787564 was equal to €1, which gives an indication of what the admission price would be in today's money.

BELOW: This photograph of a packed Silver Slipper dance, taken from the balcony, gives an idea of its popularity from the 1960s to the 1980s. On the back wall can be seen a series of painted panels by the Sligo artist Bernie McDonagh, depicting Strandhill scenes featuring the sea, Benbulben and a violinist playing against a background of Knocknarea. *(Photograph kindly made available by Roy Kilfeather.)*

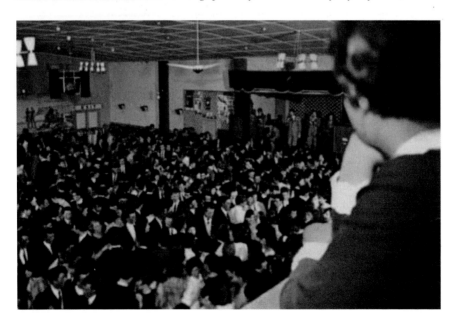

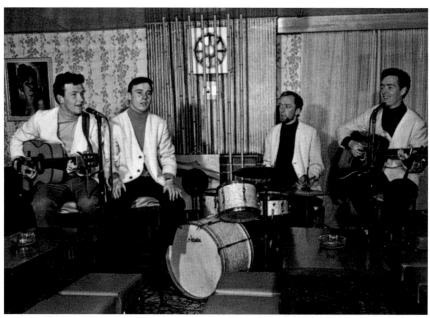

The Baymount lounge featured a resident ballad group that performed on Thursday and Friday nights in the late 1960s and 1970s. The group were (left to right): Donal McLynn, singer Michael Dunbar, drummer Dominick Smith and Roddy Gillen. (*Photograph kindly made available by Roy Kilfeather.*)

3.
What Strandhill Looked Like

When Benjamin Murrow bought property in Carrowbunnaun in 1895 he decided to develop it as a seaside resort. He built this road to join the present Top Road (R292) with the seashore and called it Buenos Ayres Drive. The road was private and gated at first, and people were charged for using it. It became a public road in 1928. On the right can be seen the castellated walls of Murrow's house, which was built in 1920, and the cannon that graced its garden. The walls on the left surround the Atlantic Hotel, built in 1910 by Michael Ballantine. (*Photograph part of the Murrow collection and kindly made available by the Byrne family.*)

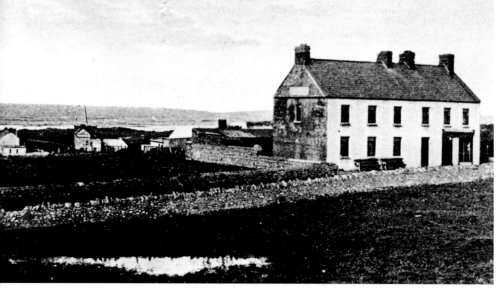

The Atlantic Hotel was built by Michael Ballantine on a plot leased from Benjamin Murrow at the junction of the new Buenos Ayres Drive and the Top Road (foreground). This was the same Michael Ballantine who ran the one-room school in Larass. A new owner, Christopher Devereau, added a ballroom in 1926 and the veranda and bay windows. It was later owned by Patrick Maguire, George and Rose Monson, and Arthur Burke. When Joe and Ita McMorrow bought it in 1957, they ran it as the Sancta Maria. It was finally called Kelly's pub before it was converted into a private residence. The gable wall of the Waverley Hotel can be seen in the middle background, so this photograph was taken after the Waverley was built, which was in 1914. The white house on the left was occupied at one time by a Garda O'Brien. *(Photograph part of the Murrow collection and kindly made available by the Byrne family.)*

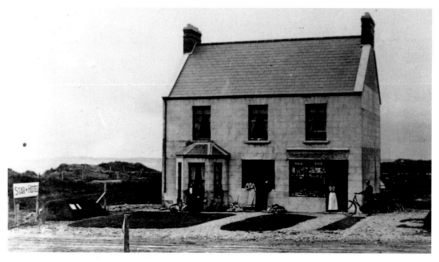

The Star Hotel was built at the shore end of Buenos Ayres Drive in 1912 by Edward Howley of Sligo. Its second owner, Ellen MacDermott, called it Star of the Sea when she bought it in 1919. In 1946 it became the Golf Links, owned by Mick Noone, reflecting the development of Strandhill Golf Course in 1931. A large collection of bicycles is stacked against the right end wall, showing that, as well as horse and cart, bicycles were a popular form of transport. Since the sign on the left still calls it Star Hotel, the photograph probably dates from before 1919. *(Photograph part of the Murrow collection and kindly made available by the Byrne family.)*

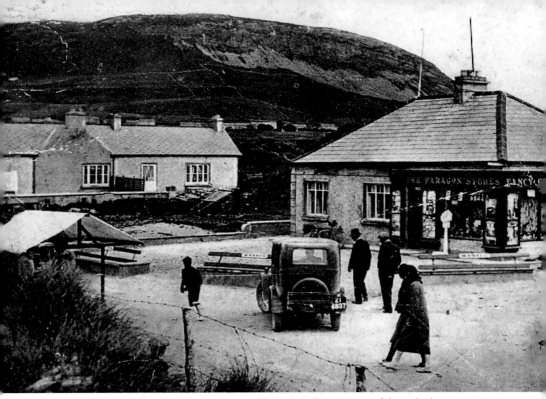

Located at the seafront, Paragon Stores, owned by Jack Cullen, was one of the early shops in Strandhill. The ZI registration number on the car plate means it was registered in Dublin city. From 1903 Ireland used the British system of car registration numbers, with a letter code followed by a sequence number of 1 to 9999. In 1927, Dublin City ran out of its original number code and adopted ZI, which means the photograph was taken some time after 1927. The shop's wooden door is still in place in the modern Mammy Johnston's café. Just after the shop can be seen the tiled roof of a one-storey house, built in the 1920s by Patrick Flannery, who ran it as Flannery's Hotel. It later became a private house and was demolished in the 2000s to be replaced by a terrace of two-storey houses. Until recent times, the words 'Flannery's Hotel' were spelled out in shells on the concrete path outside. *(Photograph part of the Murrow collection and kindly made available by the Byrne family.)*

The view up Buenos Ayres Drive from the direction of the shore. The road was built by Benjamin Murrow before 1910, when Michael Ballantine built the Atlantic Hotel. In the distance Murrow's residence, Buenos Ayres House, with its curved, castellated wall, built in 1920, can be seen. The road is fenced but cart tracks show it is not yet fully paved. In the middle distance the 'green road' from Carnadough joins the new road, but St Patrick's Catholic church, completed in 1921, where the two roads meet, does not yet appear. *(Photograph part of the Murrow collection and kindly made available by the Byrne family.)*

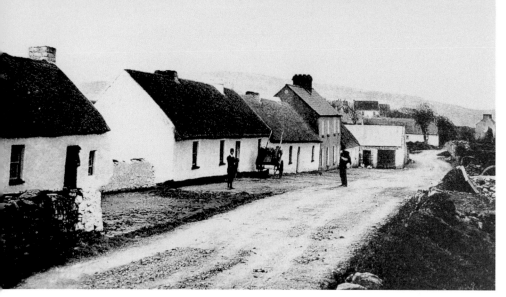

Thatched houses and a two-storey slated home in Mannionstown in Larass townland in 1906, all occupied by members of the Mannion family. This area was in the heart of old Strandhill before the seafront was developed.

The occupants were (houses left to right): Johnny (Toss) Mannion and wife Olive; Jimmy Mannion, father of 'Red' Hanna, who became Mrs Kivlehan; (with trap) Malachy Mannion, father of Paddy Mannion; Johnny and Katie Mannion, whose two-storey house was later occupied by their daughter Hanna, who ran the family shop in the thatched house next door. This single-storey house was later raised to two storeys and slated. The building sticking out was a shebeen run by Johnny Mannion's father, Denis Mannion, and wife Catherine Jones, in the nineteenth century. The section with the large door was removed by Sligo County Council in the early 1900s and the part with the small door was taken off in the 1980s, when the road was widened.

The main road turned sharp left beyond this. The house facing the crossroads was Michael Mannion's and to the right was the small laneway that became the Burma Road. The next house on the right of the lane was owned by a member of the Walker family of Rathcarrick, and later by Tommy Uncles. On a height above Michael Mannion's can be seen the original post office, owned by Willie Parke, almost opposite the old RIC barracks, which later became the Cosgrove family home. Eleven Mannion families occupied houses in Mannionstown. *(Information and photograph kindly made available by Sean Mannion.)*

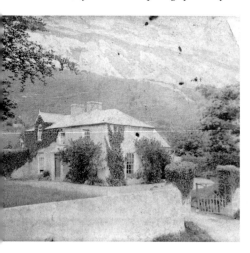

Bocage house in Culleenamore townland seen from the main road around the 1920s. The 1819 Larkin Map of Sligo shows ten adjacent houses or out-houses at Culleenamore. A map drawn up for the Barrett estate, also in 1817, records in this area an 'orchard, haggard field, dwelling house and garden in front of said field'. It showed a 'garden reserved to W. Barrett' (who was the landlord) and a piece of ground bearing the name 'Travers Homan Esq., part of Culleenamore'. Catherine Barrett, the daughter of William Barrett the Younger, who died in 1832, married Travers Homan. The Bedford survey map of Sligo Bay, prepared in 1852, showed Bocage by name at that location. (*Photograph kindly made available by the Mannion family.*)

Bocage house around the 1920s, viewed from the side and rear. Later it became vacant for a long time and it was then occupied, from the 1990s, by Packie Kennedy, who had previously lived in Carnadough. Some time after his death in 2002, it was sold and demolished, and a modern house was built on the site in 2017. *(Photograph part of the Nuttall collection and kindly made available by the Mannion family.)*

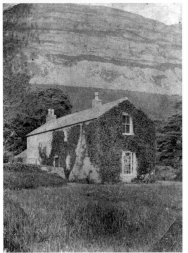

Rockville House, Culleenamore, is recorded on the 1852 Bedford survey map of Sligo Bay. The second edition of the six-inch Ordnance Survey map of 1900 described it as a bathing lodge. It was occupied at one time by Gerry Hyde, a bank manager, and then Mabel Patterson in the 1980s, whose garden was noted for its daffodils. A single-storey extension was added to the left wall in the 2000s. The cliff behind this house was called Barrett's Rock, after the Barrett family who owned the land here. People in Larass/Tully often said: 'It's an awful day; the wind is from Barrett's Rock.' *(Photograph part of the Nuttall collection and kindly made available by the Mannion family.)*

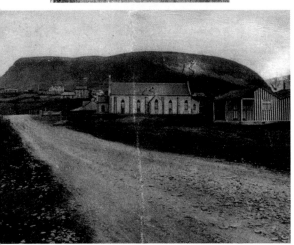

St Patrick's church, to the right of the road, was completed in 1921 so this photograph was probably taken in 1922. On the hill in the background can be seen the three-storey Waverley hotel, completed in 1914, and to its left is Benjamin Murrow's residence, Buenos Ayres House. The road is un-paved and there is no wall around the church. John and Ned Power and Ned Callaghan were among the people who lived in the striped, timber cottages on the far right. *(Photograph kindly made available by Andy Higgins.)*

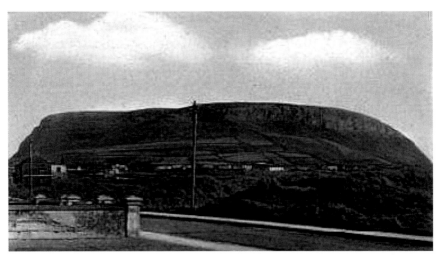

In this postcard, originally coloured, Buenos Ayres Drive is becoming more developed with walled front gardens and ESB poles. The picture was taken from Beach House, which is still in place along with the gate pillars and wall. Swan Villa, built in 1912, can be seen at left with the Baymount, built in the 1920s by Jack Byrne, behind it.

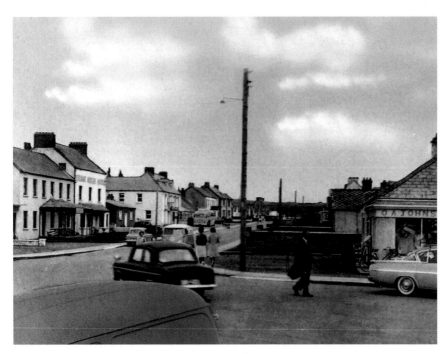

The seafront in 1959 with the Strand and Golf Links hotels on the left and Johnston's shop, in the building once called the Paragon Stores, on the right. On the left, the front of the Strand Hotel has an added veranda that was bought when the Phibbs family home, Seafield House, at Lisheen, was sold in the early 1940s and various features were bought by local people. When this was erected, the shop and hotel were owned by George Parke. *(Photograph kindly made available by the Byrne family.)*

 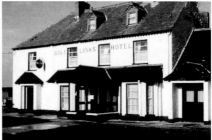

ABOVE LEFT: The Swan Villa hotel, Buenos Ayres Drive, built by Elizabeth Carew in 1912 and later owned by the McWeeney family, taken in the early 1980s. (*Photograph kindly made available by Hugh MacConville.*)
ABOVE RIGHT: The Golf Links hotel in the early 1980s. It was the first hotel to be built at the seaward end of Buenos Ayres Drive, in 1912. It was extended at various times and when put for auction in 1943 it had forty-five rooms. (*Photograph kindly made available by Hugh MacConville.*)

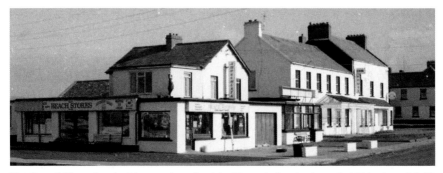

The Strand House hotel with veranda and original bay window in the early 1980s, joined (left) to the building that was originally George Parke's shop in the late 1920s. The Strand House was built in 1913 and bought by the Byrne family in 1982. It is now run as the Strand Bar. (*Photograph kindly made available by Hugh MacConville.*)

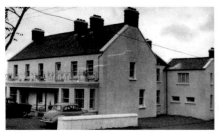 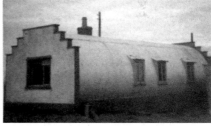

ABOVE LEFT: The Atlantic Hotel as it was in the 1960s when it was owned by Joe and Ita Mc-Morrow, who renamed it the Sancta Maria. ABOVE RIGHT: The Nissen hut was a prefabricated military building, often used as a barracks, which was used widely during WWII. It was made of curved, corrugated metal with door and window openings. A lot came on the market after WWII and were bought for use as private housing. Strandhill had three, of which two, located where the modern surgery now stands on Buenos Ayres Drive, are gone. This one still survives but has been built into a modern, brick building on Buenos Ayres Drive. In its day it was comfortable and beautifully decorated in modern style and occupied by Ernie and Molly Daly. (*Photograph kindly made available by the Byrne family.*)

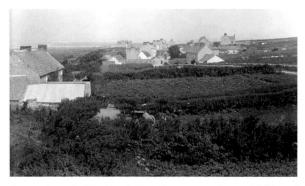

A view along the Top Road (R292) showing cultivated fields and a farmhouse where the Summerville nursing home is now located. In the middle distance, left, can be seen the thatched house that became the old post office run by the Keane family, now a slated, two-storey building.

The southwestern slopes of Knock-narea and the Ox Mountains taken from the northwest in the early 1970s. Four haystacks are located where a modern barn now stands. *(Photograph kindly made available by the Mannion family.)*

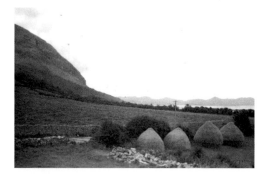

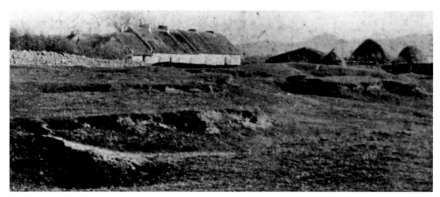

Carnadough hamlet at Culleenamore beach in 1913. The two thatched houses and adjoining shed were modernised in the 1960s and a two-storey house replaced part of one in 2000. They were originally occupied by the Mannion family and the McLoughlin brothers. There were other thatched cottages further up the sandy lane, which was upgraded in the 1960s to become the road to Culleenamore beach (L35053). The stone wall on the far right was built by the landlord William Barrett in the early nineteenth century to separate tenants' vegetable gardens from the old Ballisodare to Sligo road, which ran along the shore in front of the houses. Carnadough is recorded in the Down Survey of 1656-1658, which measured the lands to be confiscated from the Irish. *(Photograph part of the Murrow collection and kindly made available by the Byrne family.)*

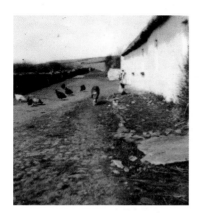

The street of Carnadough, beside Culleenamore beach, taken from just south of the Mannion family house. Chickens peck at the ground and the path is unpaved. The houses are thatched. At the extreme right a fuchsia bush grew and next to it was the doorway of the adjoining house, occupied by two brothers called McLoughlin, one of whom was blind and the other deaf. The flagstone that was outside their front door can be seen on the right. The dog's name was Fly. *(Information and photograph kindly made available by the Mannion family.)*

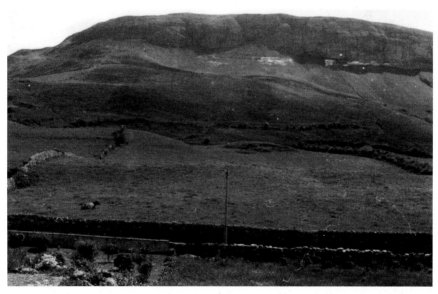

Knocknarea and the Top Road (R292) at Carnadough townland in the 1960s, before new houses were built or forestry planted. The land below the mountain used to be one single field, part of the Barrett estate, which ran from Culleenamore to Carrowbunnaun townlands. The Top Road (R292), built in 1836, cut through the Barrett field. Tenants in five houses beside Culleenamore beach, Kellys, Howleys, Boles, McLoughlins and Mannions, and Gillens also, leased part of that field and each had a stone wall, gate piers and an iron gate into the field. On a stone gate pillar near the turn for Culleenamore beach (L35053), the date 18036 is carved. It is believed the pillar was originally located on Barrett land at Culleenamore with the date 1803 and that it was re-used to build the new gates and the number six added, to mark the date the road was built. When first built, it took 12 men to build the field wall. *(Information and photograph kindly made available by the Mannion family.)*

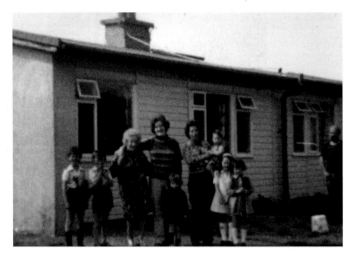

The four single-storey houses beside Culleenamore beach were originally timber chalets with felt roofs and were let to summer visitors. Seen here, in the mid-1970s, is Kathleen Devins (*née* Mannion, fourth from left) with the Hanley family, visitors from Carrick-on-Shannon. Blockwork walls and slate roofs were added to the houses in the early 1980s. *(Photograph kindly made available by the Mannion family.)*

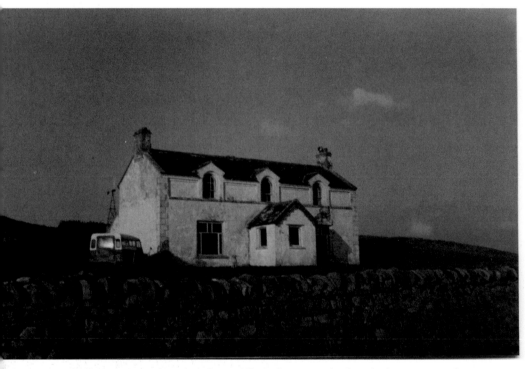

Walker's or Doonagleeragh Lodge in Killaspugbrone townland was built as a summer house by Robert Chambers Walker of Rathcarrick around 1851. It was empty for some time and is pictured here in 1986 as it was being renovated by Noel Carter. Irish army soldiers were billeted at Walker's Lodge during WWII, in approximately 1944. The Bree family of The Bridge, Larass, used to supply them with milk. *(Information from Donald and Joan Bree. Photograph kindly made available by Brid Dolan.)*

The Dolan family lived in the first house on The Line. They were farmers and produced hay and cattle with a small amount of tillage, mostly cabbage, turnips and potatoes. They, and other local farmers, left their milk in churns like these at the top of the road from where the Drumcliffe creamery van collected them each morning. At the creamery the milk and cream were separated, leaving skim milk. In the evening the van brought the skim milk back in the churns and it was used for feeding calves. This photograph was taken outside the Dolan family house. *(Information and photograph kindly made available by Brid Dolan.)*

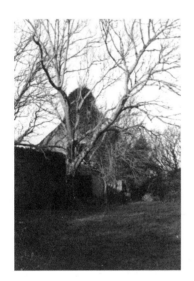

Strandhill House sits at the seashore in Rinn townland, hidden behind a high stone wall, beside what was once the old road from Ballisodare to Sligo. The house was built in the early eighteenth century, probably by the wealthy Ormsby family at Cummin. In 1835 it passed to the Meredith family, who lived at Primrose Grange on the Glen Road. The Merediths lived in Strandhill House until the death of the last Meredith, John, in 1964. The Land Commission divided the lands and the house was left unoccupied. This photograph, showing the gable end and adjoining wall, was taken in 1986. *(Photograph kindly made available by Brid Dolan.)*

An old cottage in Rinn townland in 1986, which is still occupied. The main road from Ballisodare to Sligo originally came along the shore by Rinn and went north to Sligo. When the Top Road (R292) was built in 1836 it went only as far as St Anne's church then turned down into Rinn and came out at Carter's Corner, where the Rinn road still joins the main road. The stretch of road from St Anne's Church to that junction was built about 10 years after and was called The New Line. *(Information from Denis Mannion, deceased, and photograph kindly made available by Brid Dolan.)*

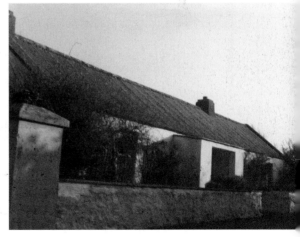

Top: A traditional, stone lean-to cart shed in Rinn, still in existence. It could also have been used to store turf and farming equipment.

Bottom: An old stone house in Rinn in 1986 with lead and diamond-paned window. It was once home to the Curran family. The house was restored and is now occupied. (*Information from Andy Higgins and photograph kindly made available by Brid Dolan.*)

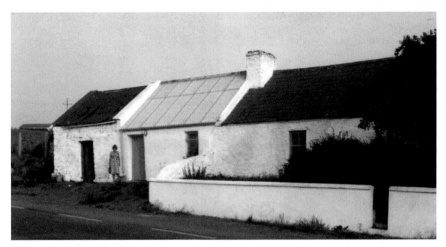

Thady Higgins' house, which was once thatched, in 1976, with Mary Kate Higgins seen outside the kitchen door on the left. The 'room' part of the house was the slated section on the right. Inside, a door beside the kitchen window connected the room and the kitchen. The house was originally the home of a herd on the Walker estate called Bradley, who was drowned between Killaspugbrone and Maguin's Island. Thady's father, also called Thady, was made the herd and given the house. His son Thady lived there until he died. (*Information and photograph kindly made available by Andy Higgins.*)

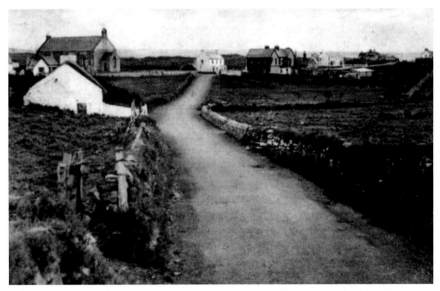

A view down the old Walker estate farm track that was called Thady's Lane, with Thady Higgins' cottage on the left and St Patrick's hotel, later called The Kincora, at the end right. The lane became the Burma Road in 1945, when it linked Mannionstown with Buenos Ayres Drive. Thady Higgins named it 'the Burma Road' because, when the new road was opened between his cottage and the church, people living on Buenos Ayres Drive objected and put tar barrels across it. They feared fewer people would pass their premises and they would lose business. Thady told Pat Ward it was 'worse than Burma here'. (*Information and photograph kindly made available by Andy Higgins.*)

4.
Dolly's Cottage

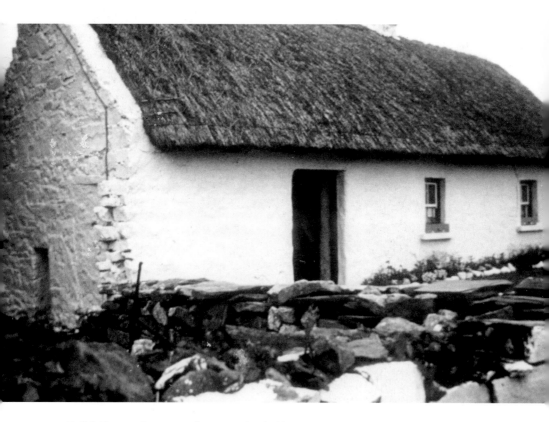

Dolly's Cottage, the nineteenth-century thatched house in Larass townland, where early Strandhill was located. It was originally on land owned by the Walker estate of Rathcarrick, and the area was also known as Foleystown. The house was marked on the first Ordnance Survey map of the area, which was produced in 1837. Though it is not known who first lived there, it was home to three generations of the Bruen family, to whom Andrew Bruen was born in the 1840s. A substantial house by the standards of the time, it is the last thatched house in Strandhill, although most Strandhill families lived in thatched cottages at one time.(*Photograph kindly made available by Strandhill Guild, ICA.*)

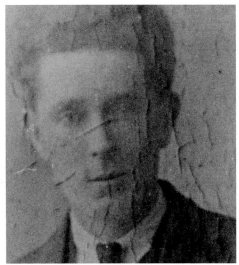

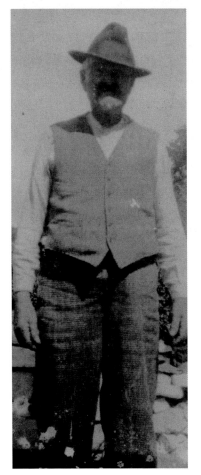

ABOVE LEFT: Dolly Higgins, last resident of Dolly's Cottage, in 1967. Andrew Bruen, of the Bruen family that originally lived in the cottage, had two daughters, Kate and Ellen. In 1898, Kate Bruen married Tom Higgins, whose family had moved to the area from Coney Island. Andrew Bruen signed over the house and a one-acre farm to them and Big Tom moved into the cottage with Kate and her family. In 1899, Kate had a son, Francis, followed in 1901 by twins Tom and Mary Kathleen (Dolly), but Kate died in childbirth. Dolly lived in the house with her father, Big Tom, who died in 1951. She and Big Tom gathered and sold seaweed, Sleabhcán, which they brought by horse-and-cart to Sligo and sold in the Market Yard. It was a popular dish – especially on Fridays, when Catholics did not eat meat. Her home was a rambling house where people dropped in for a chat. She died in 1970.

ABOVE RIGHT: Francis Higgins, Dolly's older brother. He married in 1929 but died in 1937, leaving a widow, Nellie, and two children, Evelyn and Andy.

LEFT: Big Tom Higgins, father of Dolly Higgins. He gave Kate's father a £20 dowry or payment when he married Kate Bruen, as well as an undertaking that Andrew Bruen could live there for the rest of his life and that Big Tom would not do anything to endanger the Bruen family's tenancy. They paid £2 a year rent to the Walker estate for the cottage. Big Tom had a habit of saying, when it was cloudy and going to rain: 'There's a regular hape of skitter over there.' (*Information from Andy Higgins and photographs kindly made available by Strandhill Guild, ICA.*)

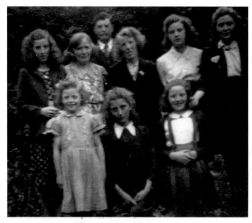

Dolly Higgins (back row, second left) with neighbours (back row) Patrick Foley, husband of Mary-Ann Bree (second row, third left), one of the Bree family who lived in a thatched corner house at the junction of The Bridge and The Line. Patrick Foley was descended from the Meredith family, who lived in Strandhill House at Rinn shore. Second right is Patrick and Mary Ann's daughter, Cis (Mary) Foley. Front row, first left is Marie Bree, centre Bridie Mannion of Man-nionstown, and first right Joan Bree. (*Information and photograph kindly made available by Donald and Joan Bree, The Bridge.*)

Evelyn Murray, daughter of Francis Higgins and niece of Dolly Higgins. She was a long-time, active member of the Irish Countrywomen's Associa-tion, which, in 1970, bought Dolly's cottage when she died and preserved it for future generations. (*Information from Donald and Joan Bree. Photograph kindly made available by Strandhill Guild, ICA.*)

The interior of Dolly's Cottage, unchanged since Dolly lived in the house. The hearth has a crane that allowed pots to be swung out over the fire for cooking. The doorway on the right leads to the parlour, and a built-in pouch bed, a feature of many traditional cottages, can be seen on the left. The ceiling is open to the thatch, which has been there since the time of the Famine. Beneath the thatch the roof was insulated with peat. A traditional wooden table, set by the window for light, flagstone floor and period ornaments complete the scene. (*Information from Deirdre Foley and photograph kindly made available by Strandhill Guild, ICA.*)

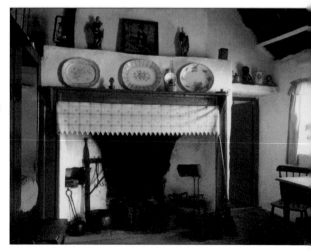

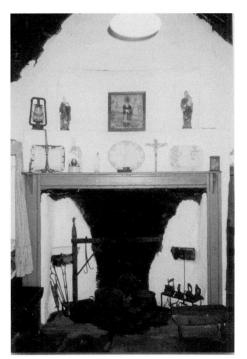

This picture of the cottage hearth, without the oilcloth trimming on the mantelpiece, shows a set of metal clothes irons on a stand beside the fire, where they would have been heated before use. Long pokers and a bellows can be seen on the left and there is a space built into the fire surround that would have been used to store food that needed to be kept dry. *(Photograph kindly made available by Strandhill Guild, ICA.)*

The curtained pouch bed close to the fire, which was made from shipwreck timber salvaged from the shore. This design was a feature of traditional cottages in the north-west and west of Ireland. It allowed a family member, perhaps grand-parents, to sleep near the warmth of the fire. Space for these beds was provided by building an outshot or alcove that projected beyond the line of the back wall. A St Bridget's cross had been tucked into the thatch above the bed when the house was built at the time of the Famine and is still there. It is circular in shape, unlike the well-known St Bridget's cross design of today. The model ship above the pouch bed was made by Big Tom. *(Information from Deirdre Foley and photograph kindly made available by Strandhill Guild, ICA.)*

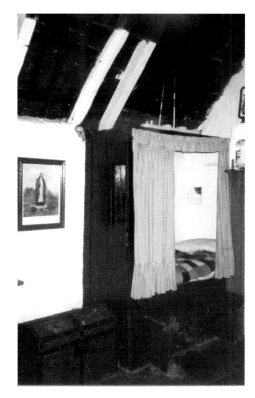

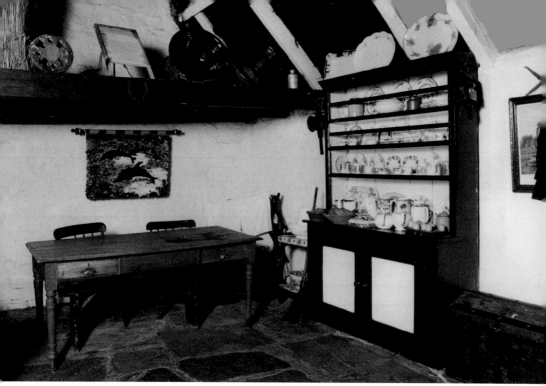

The back end of Dolly's main room, showing the dresser where delph was held and the loft, originally reached by a ladder, where family members might sleep. On the loft are displayed two pottery bowls, probably used for skimming milk, a wooden washboard and the paddle of a dash churn used for making butter. The cottage also has handwoven willow baskets that were used for straining potatoes, old carpentry tools, and lamps that were used for the sides of carts to light their way. (*Photograph kindly made available by Strandhill Guild, ICA.*)

The elaborate mantelpiece in the parlour probably dates to later than the house, which was built some time before 1837. It indicates the relative prosperity of the family; Dolly's cottage was a substantial home by the standards of the mid-nineteenth century. Big Tom Higgins worked for the Walker estate and for Benjamin Murrow. It is possible the mantelpiece came from one of them. (*Photograph kindly made available by Strandhill Guild, ICA.*)

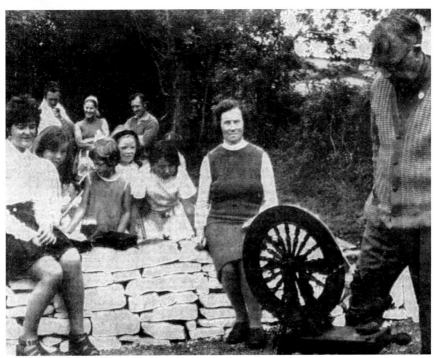

Following the death of Dolly Higgins in 1970, the Strandhill Guild of the Irish Country-women's Association (ICA) bought her empty home and restored it. It opened to the public as a museum and craft shop in the summer of 1971. Deirdre Foley (left), pictured here at the opening, has been actively involved in the ICA and care of Dolly's Cottage for many years. The man beside the spinning wheel is Paddy O'Brien and the woman at the centre is Kitty Scanlon, who lived in a house at Rinn shore that used to be a former seaweed baths. (*Information from Deirdre Foley and photograph kindly made available by Strandhill Guild, ICA.*)

Dolly's Cottage – Strandhill's new tourist attraction

Just over £2 million or 11.8 per cent of the National figure, was spent by tourists on purchases in the North-West last year, revealed Mr. Eamonn Hoy, North-West Regional Tourism Manager, when he spoke at the opening of the I.C.A. Cottage Museum and Craft Shop "Dolly's Cottage", at Strandhill last Sunday.

"We hope to see this figure increased", he continued, "The spending on purchases by visitors spreads the benefits of tourism widely to the community; the craft shop here in Strandhill and similar projects can contribute to the hoped-for expansion".

Conscious of the important role which Strandhill could play in the expansion of tourism in the North-West, Mr. Hoy said, the Regional Tourism Organisation had decided to support financially a number of projects in the locality. They were making a grant of £300 towards the Museum/Craft shop project; a grant

The niece of the last owner of the cottage, Mrs. E. Murray, also congratulated the Guild.

The museum and craft centre is housed in a cottage purchased by the Strandhill Guild of the I.C.A. whose forty members determined to restore it to its authentic original state and to preserve it as a relic of past generations. They hoped also that it might serve as an incentive to future generations, since it so clearly indicates the advancement of the Irish nation over the last two centuries.

The date of the erection of the cottage is unknown, but its architecture points to a date somewhere after the year 1800. It has a type of open fireplace which was only then coming into general use.

Originals

The walls, roof, fireplace and loft beams are the originals used and no alterations have been made.

Among the features of the house is the pouch bed in the chimney corner, a typical object of 19th century Western rural cottages which, however, were more common in midland or east coast dwellings. The cottage itself is typical of a Western tenant farmer or labourer.

The first occupants of the house are unknown, but it became the property of a family names Bruen and three generations of that name were reared there with the female heir eventually marrying a Higgins.

The cottage, now known as Dolly's Cottage, is named after the last occupant, Miss Dolly Higgins.

A genial soul, well loved by young and old in the district, Dolly was always available to lend a helping hand to anybody in distress.

The work of restoration and decoration of the cottage was carried out by the local I.C.A. members and all the items on display in the cottage were collected or produced by themselves or their friends.

The report in *The Sligo Champion* heralding the public opening of Dolly's Cottage in 1971. (*Kindly made available by Strandhill Guild, ICA.*)

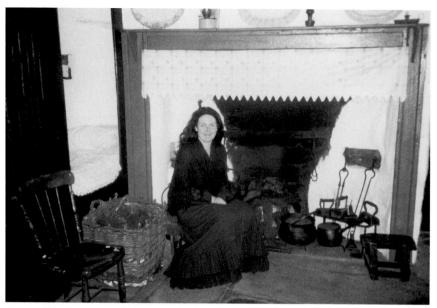

As a rambling house, people used to call regularly to Dolly Higgins' home to chat, tell stories or listen to music. The ICA has kept that tradition alive with many community social events. (*Photograph kindly made available by Strandhill Guild, ICA.*)

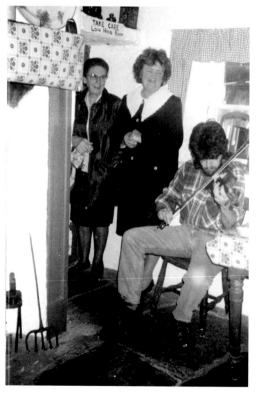

A young Seamie O'Dowd, now a famous musician, playing in Dolly's kitchen at one of the many social evenings hosted by the ICA. In the parlour doorway are Kathleen Taylor (left) and Deirdre Foley. (*Photograph kindly made available by Strandhill Guild, ICA.*)

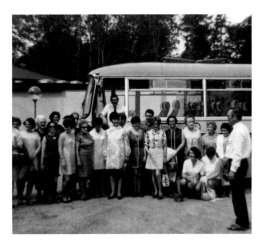

Strandhill ICA members on an outing to Connemara in Johnston Carew's bus in the 1960s. Johnston Carew is standing in the bus doorway and the man on the right is Andy Higgins. Among the group are (front row, from left): second, Bridgie O'Brien, third, Annie Feehilly, of the Waverley Hotel, in sunglasses; fourth, Deirdre Foley; fifth, Norrie Kivlehan, with sunglasses; seventh, Deirdre Chapman, and (from right), second, Liz Curran, kneeling: fourth, Alice Mannion, and fifth, Nora Dolan, whose husband, Padraig Dolan, is standing behind her. In the second row are Mrs Norah Keane (second left) and Mrs Teresa Keane (third right), who ran Strandhill post office for many years. (*Information and photograph kindly made available by Sean Mannion.*)

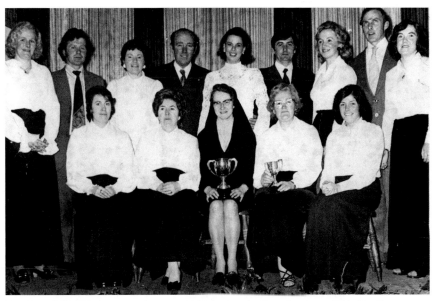

The Strandhill ICA choir, seen here in 1975 having won first place in an ICA choral competition. Included in the group are (front row, from left): Valerie Dray, Evelyn Higgins; centre, musical director Sr Marie Finan, followed by Caimin Fox and Maureen Bruen. Back row: Ailish Mallon, Tommy Bree, Joan Bree, John Keane, Maeve Carroll, Liam Verdon, Ita McMorrow, Brendan McAuley and Marian Roycroft, *née* Kiely. (*Photograph kindly made available by Donald and Joan Bree.*)

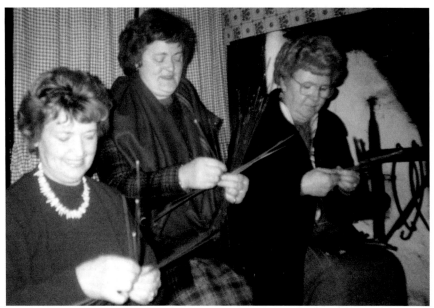

Members of Strandhill Guild ICA making St Bridget's crosses in Dolly's Cottage in 1986. Making the traditional rush cross was a long-time fundraising activity by ICA members, including (left to right): Zita Ceillier, Deirdre Foley and Evelyn Murray. The St Bridget's cross was kept in houses as protection from fire and sickness. (*Photograph kindly made available by Strandhill Guild, ICA.*)

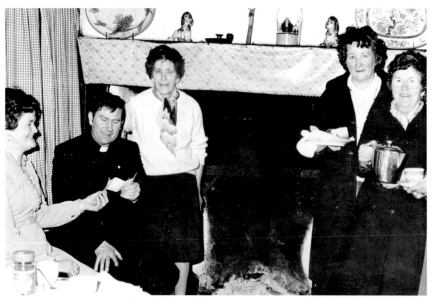

The proceeds from the sale of St Bridget's crosses are presented to Strandhill parish priest Fr Liam Devine by members of the ICA in Dolly's Cottage mid-1980s. Left to right: Deirdre Foley, Leena Mannion, Bridgie O'Brien and Evelyn Murray. (*Information from Deirdre Foley and photograph kindly made available by Strandhill Guild, ICA.*)

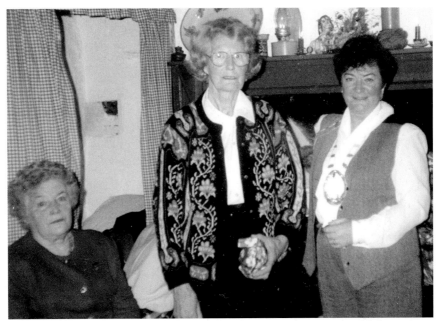

Founder member of Strandhill ICA Kathleen Parke (centre) with (left) Margaret Pilkington and the national president of the ICA, who was on a visit to Dolly's Cottage. Kathleen Parke ran the guesthouse (later hotel) called the Ocean View on the Top Road. (*Photograph kindly made available by Strandhill Guild, ICA.*)

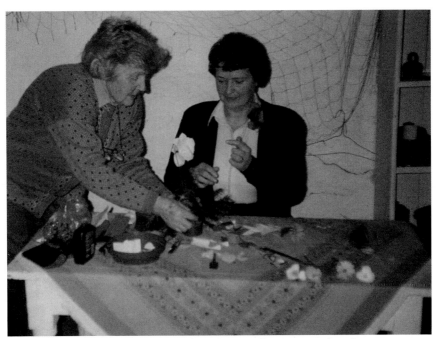

ICA members Kathleen MacConville (left) and Zita Ceillier preparing for a flower-arranging competition, mid-1980s. (*Photograph kindly made available by Strandhill Guild, ICA.*)

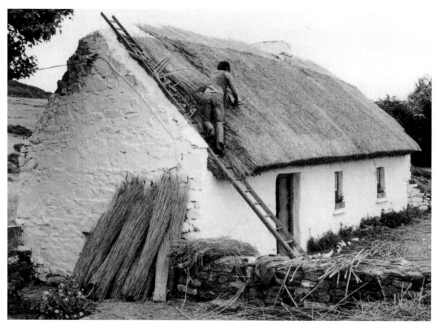

Dolly's Cottage was rethatched before its opening, by local man Tom 'the Thatcher' Gilgan, who used traditional straw. Each thatching lasted about five years. As years went on, hand-cut rye straw could not be sourced, so when thatcher Paul Rippon, seen here, rethatched the roof in 1982, longer-lasting reeds had to be used. The thatch was repaired after it caught fire from a spark blown from fire embers. When the thatch caught fire, the turf underneath started to smoulder, and it was spotted by the driver of the local bus, Joe Chrystal. He stopped the bus, and he and the passengers threw water on the fire until the fire brigade arrived. (*Information from Deirdre Foley and photograph kindly made available by Strandhill Guild, ICA.*)

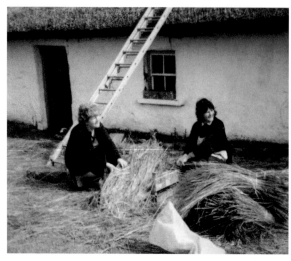

ICA members help prepare reeds for rethatching the roof of Dolly's Cottage. About one-quarter of the roof at the front had been lost in the fire. (*Photograph kindly made available by Strandhill Guild, ICA.*)

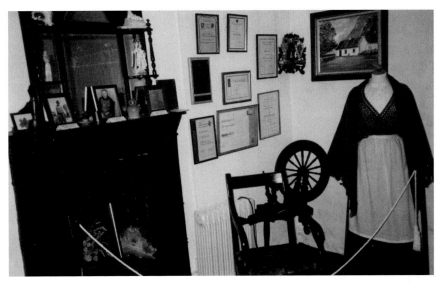

Part of the heritage display in the parlour of Dolly's Cottage in 2000. The apron on the mannequin was made from a bleached flour bag. It was secured by the ICA when they took over the cottage and is a reproduction of what women wore in the past. Such bags were used for a lot of domestic items. (*Photograph kindly made available by Strandhill Guild, ICA.*)

ABOVE LEFT: Postcard of Dolly's Cottage produced by Strandhill Guild of the ICA. (*Image kindly made available by Strandhill Guild, ICA.*)
ABOVE RIGHT: Invoice from builder Peter Savage, Kilmacowen, for carrying out renovations to Dolly's Cottage, including putting in water and toilet facilities, in 1992. (*Kindly made available by Strandhill Guild, ICA.*)

5.
Families of Strandhill

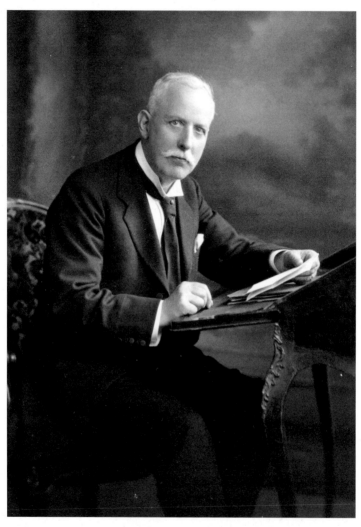

Benjamin Murrow, originally from Belfast, came to Sligo in the mid-1880s, bought land in Carrowbunnaun in 1895, and set about developing his property as a seaside resort. He built Buenos Ayres Drive to open access to the seashore and, in 1912, built seaweed baths at the seafront. (*Photograph part of the Murrow collection and kindly made available by Geraldine Murrow.*)

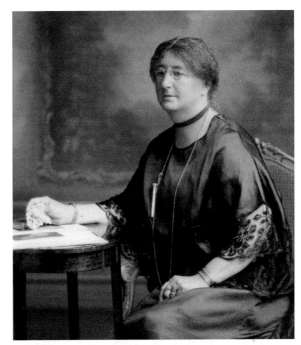

Isobel, wife of Benjamin
Murrow. (*Photograph part
of the Murrow collection and
kindly made available by
Geraldine Murrow.*)

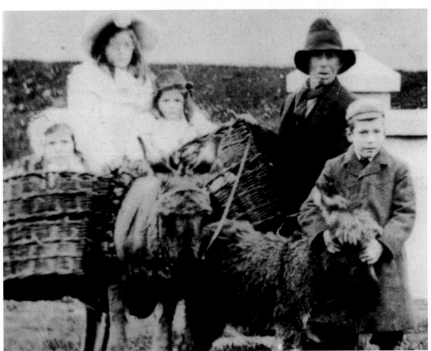

Benjamin Murrow's children (l-r): Jean, Ella, Alice, who died young, Pat Ward, who worked
for Benjamin Murrow, holding basket, and Stuart Murrow with an ass foal. (*Photograph part of
the Murrow collection and kindly made available by Geraldine Murrow.*)

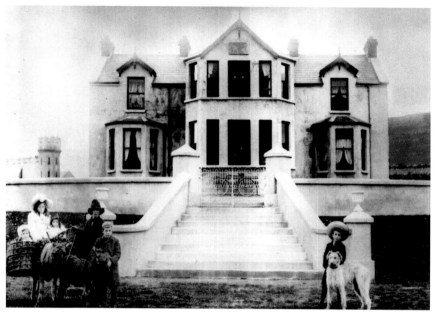

The Murrow family residence, Buenos Ayres House, which was the first house built on Buenos Ayres Drive. The grounds, which included a lawn, croquet pitch, tennis court and orchard, were surrounded by a castellated wall (background, left). On the east-facing lawn he set two cannon he had bought from Sligo Militia artillery battery at Rosses Point. The third was set up at the seafront and is still in place. The house was later bought by Willie Parke, who replaced it with a bungalow. The ruins of this house were demolished in early 2019. (*Photograph part of the Murrow collection and kindly made available by Geraldine Murrow.*)

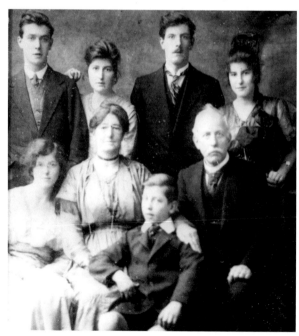

Benjamin Murrow and family *c.*1920s, with (back row, right) his son Stuart Murrow who inherited and ran the family business and seaweed baths in Strandhill. (*Photograph part of the Murrow collection and kindly made available by Geraldine Murrow.*)

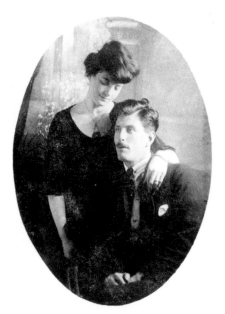
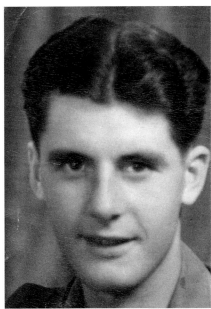

ABOVE LEFT: Stuart Murrow and his wife, whom he called 'Girlie'. Stuart Murrow and his wife were parents of the third generation of Murrows. (*Photograph part of the Murrow collection and kindly made available by Geraldine Murrow.*) ABOVE RIGHT: Bennie Murrow, son of Stuart Murrow, who used to call him 'Fluff'. He lived in the UK, where he was in the RAF. (*Photograph part of the Murrow collection and kindly made available by Geraldine Murrow.*)

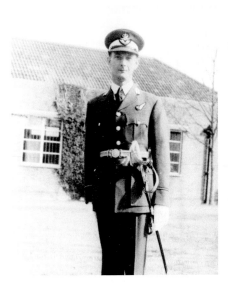
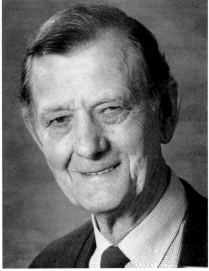

ABOVE LEFT: John Murrow, second son of Stuart Murrow, pictured on his commissioning day in 1965, when he was made an officer in the RAF. He lived in the UK, like his brothers Bennie and Bob. (*Photograph part of the Murrow collection and kindly made available by Geraldine Murrow.*) ABOVE RIGHT: John Murrow in later years. (*Photograph part of the Murrow collection and kindly made available by Geraldine Murrow.*)

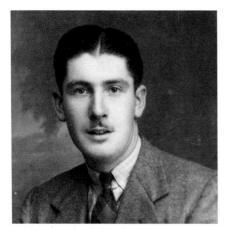
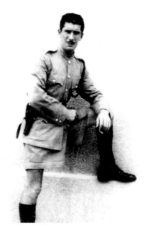

ABOVE LEFT: Bob Murrow, third son of Stuart Murrow. He lived and worked abroad, including the UK, for many years but on retirement returned to live at Luffertan and later Sligo town. (*Photograph part of the Murrow collection and kindly made available by Geraldine Murrow.*) ABOVE RIGHT: Bob Murrow in the uniform of the Palestine Police Force. This was a British-run police service established in July 1920 in Palestine, while it was under British Mandate. It followed the surrender of the Ottoman Empire in October 1918, which ended Ottoman activity in the First World War. The force came to an end when the Jewish population of Palestine declared independence on 14 May 1948, the day before the British Mandate was due to expire. Bob Murrow had joined it in 1944. (*Photograph part of the Murrow collection and kindly made available by Geraldine Murrow.*)

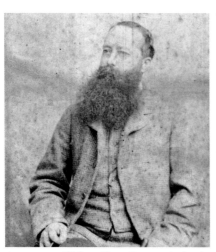
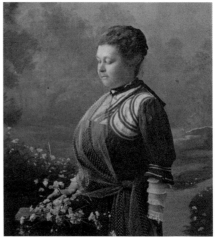

ABOVE LEFT: William Knox Barrett, the last landlord of that name to own the Barrett estate in Culleenamore. He was well liked but died in 1888 aged forty-five. He left his estate to his widow, Elinor Kate Barrett née Homan. (*Photograph part of the Nuttall collection and kindly made available by the Mannion family.*) ABOVE RIGHT: Elinor Kate Barrett, widow of William Knox Barrett. In 1889 she married Aeneas Falkiner Nuttall of Newtownmountkennedy, County Wicklow, and they lived at Culleenamore House, the Barrett home. In the early 1900s, Elinor Kate started Culleenamore Violet and Shamrock Farm and supplied shamrock every year to Buckingham Palace for St Patrick's Day, as well as violets. She died in 1921. (*Photograph part of the Nuttall collection and kindly made available by the Mannion family.*)

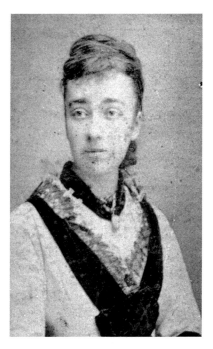

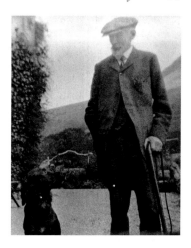

ABOVE LEFT: Helena Barrett, sister of William Knox Barrett of Culleenamore. (*Photograph part of the Nuttall collection and kindly made available by the Mannion family.*)

ABOVE RIGHT: Aeneas Falkiner Nuttall, who married Elinor Kate Barrett and lived at Culleenamore. He and Elinor Kate had five children. A writer in 1898 said of Aeneas Nuttall that he kept 'splendid specimens of horses and dogs'. Their eldest son, Freeman Aeneas Nuttall, returned to live at Culleenamore in 1921 after his death. (*Photograph part of the Nuttall collection and kindly made available by the Mannion family.*)

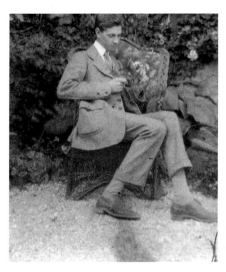

Freeman Aeneas Nuttall, eldest son of Aeneas Falkiner and Elinor Kate Nuttall, aged twenty-two in 1913, probably photographed at the veranda at Culleenamore House. He worked in Germany and Canada before returning to inherit the Culleenamore property. He was a prize winning horticulturalist and planted extensive gardens at Culleenamore. In old age, he lived with the Mannion family at Carnadough and died, unmarried, in 1968, aged seventy-eight. (*Photograph part of the Nuttall collection and kindly made available by the Mannion family.*)

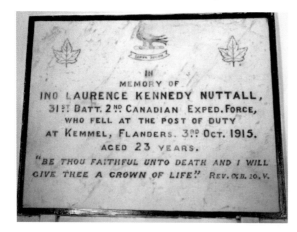

ABOVE LEFT: A plaque in St Anne's church in memory of Ino Laurence Kennedy Nuttall, second son of Aeneas Falkiner and Elinor Kate Nuttall. In October 1915, he was killed in Flanders while serving with the Canadian Expeditionary Force during the First World War. He was twenty-three.

ABOVE RIGHT: Freeman Aeneas Nuttall photographed in 1918, aged twenty-seven. From the family's landscape garden at Culleenamore, he and his mother used to supply violets to Buckingham Palace. They were grown on the part of the Culleenamore grounds where a large stone was erected, c.1900, to mark the grave of a pet dog called Prince. (*Photograph part of the Nuttall collection and kindly made available by the Mannion family.*)

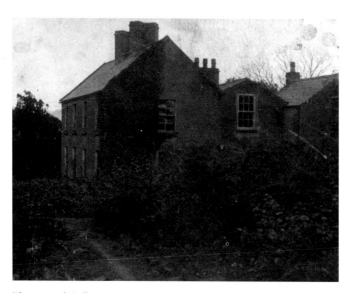

The original Culleenamore House, owned first by the Barrett and then the Nuttall families. Freeman Nuttall, in time, let the house to various tenants and lived in a house across the road. He sold the house in 1957 to Johnston Carew, who, in turn, sold it in the early 1960s to John and Victoria Janet, who demolished the old house and built a modern dwelling on the site. This house is now occupied by the Maye family. (*Photograph part of the Nuttall collection and kindly made available by the Mannion family.*)

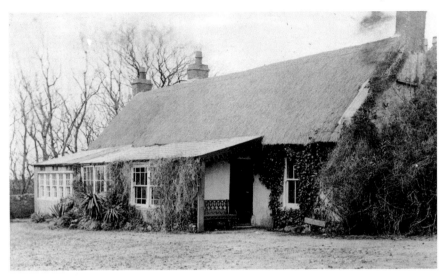

The thatched veranda at the southern side of the original Culleenamore House. (*Photograph part of the Nuttall collection and kindly made available by the Mannion family.*)

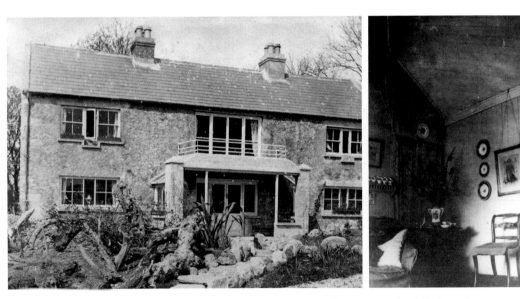

ABOVE LEFT: The modern facade at the rear of Freeman Nuttall's House. In the cliffs above this house, a tree grew beside a long, narrow cleft, which was called 'the one o'clock tree'. When the sun shone on this tree it was one o'clock and people used it to tell the time. (Photograph part of the Nuttall collection and kindly made available by the Mannion family.)
ABOVE RIGHT: The interior of a room in Freeman Nuttall's house. (*Photograph part of the Nuttall collection and kindly made available by the Mannion family.*)

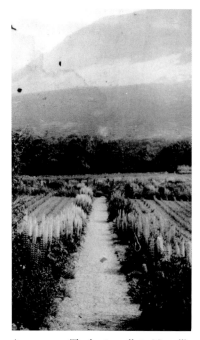

ABOVE LEFT: The lupin walk in Nuttall's gardens at Culleenamore, facing towards Knocknarea. (*Photograph part of the Nuttall collection and kindly made available by the Mannion family.*)

ABOVE RIGHT: Freeman Nuttall pictured in his garden in middle age. Both he, and his father before him, won prizes and commendation for the produce they grew at Culleenamore. One time in the 1960s, Ollie (Oliver) McLoughlin and the McMorrow brothers of the Sancta Maria raided Nuttall's orchard. They were chased away and, fearing trouble, hid out for two days in Duggan's haybarn while their families and people in Strandhill searched everywhere for the 'missing children'. (*Photograph part of the Nuttall and kindly made available by the Mannion family.*)

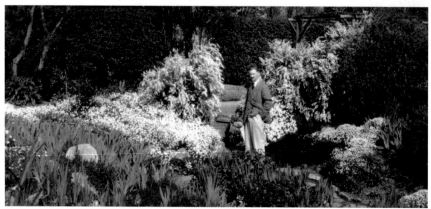

Freeman Aeneas Nuttall in the midst of his garden, which included a pergola, flagstone paths, ornamental pond, and mature trees and shrubs. As he got older the gardens were less well tended. (*Photograph part of the Nuttall collection and kindly made available by the Mannion family.*)

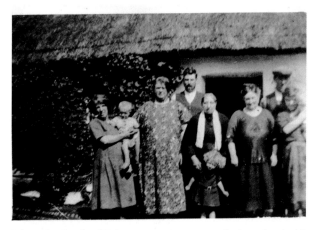

Members of the Foley family of Foleystown in Larass outside their thatched house. From left to right, back row: Paidg Foley and Francis Higgins, Dolly Higgins' brother. Front row: Mary Ann Foley, *née* Bree, holding baby Thomas Foley; the woman in the patterned dress may be Mary Foley, who went to the US; Mary Meredith, with white scarf, one of the Merediths of Strandhill House, who was mother of Paidg Foley; Mary Agnes Burns, grandmother of Andy Higgins, who was originally from Kerry but who married a Foley; Nellie Higgins (*née* Foley), wife of Francie, holding Evelyn Higgins (married name Murray) in her arms. The child standing in front is Cis (Mary) Foley. The photograph date can be estimated because Francie Higgins died in 1937, so the photograph was taken earlier in the 1930s. The Foleys in this locality date back to at least the 1600s. (*Information and photograph kindly made available by Andy Higgins.*)

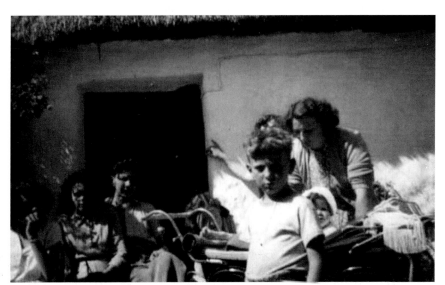

A group of people, including visitors from Dublin, outside the Foley family home at The Bridge, Larass. The woman on the right is Bridgie O'Brien of The Bridge. The house was later slated, and finally, in the 2000s, replaced by a two-storey house when Dorrins Strand housing estate was built. Next door was another thatched house, where Nellie Foley (who married Francie Higgins) lived. (*Information and photograph kindly made available by Donald and Joan Bree.*)

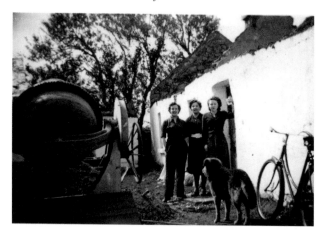

The same Foley family home at The Bridge, when its thatch had been removed in order to put on a slate roof. A cement mixer sits in foreground. Left to right: Cis Foley, Joan Bree and Evelyn Higgins. (*Information and photograph kindly made available by Andy Higgins.*)

Deirdre Foley, who has been active for many years in running Dolly's Cottage, pictured there in the 1980s. (*Photograph kindly made available by Strandhill Guild, ICA.*)

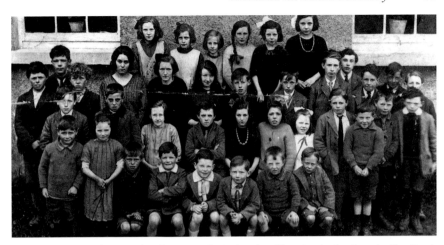

This school group photograph, taken around 1924 at the old national school on the Top Road, includes three members of the Kelly family. In the back row, first right, is Elizabeth Kelly, who married John Bree and was mother to Donald and Joan Bree. Second right is her sister Mary-Jane Kelly, who died from meningitis aged thirteen. In the second row from front, fifth right, is Kathleen Kelly, whose married name was King. The Kellys' mother was Catherine Quinn of Carracastle. The Kelly family home was in Carrowbunnaun. (*Information and photograph kindly made available by Donald and Joan Bree.*)

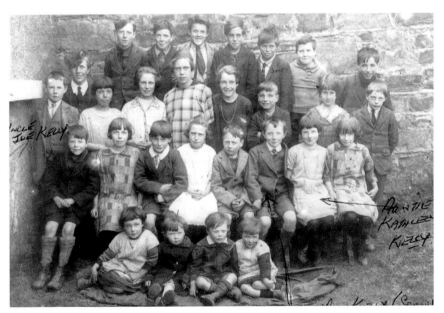

Another school group photograph taken mid-1920s, which includes (second row from front, second right) Kathleen Kelly, (third right) Matt (Sonny) Kelly, and (third row, first left) Joe Kelly, who in later life married Peg Kelly, who became a teacher in the school. Other children in the group include (back row, third right) Packie Ward, who later lived in a cottage beside the site of the Ocean View, now a two-storey county council house, and (second from right) Jimmy Howley of Carnadough. (*Information and photograph kindly made available by Donald and Joan Bree.*)

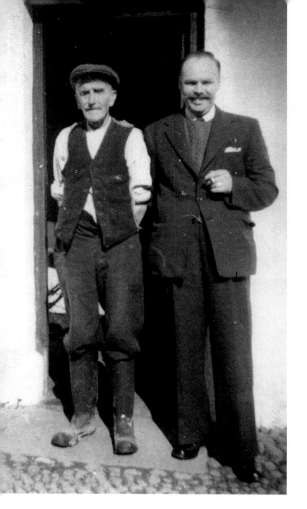

Pat Kelly (left) who worked on the Walker family's Rathcarrick estate, with his son-in-law John Ward. (*Information and photograph kindly made available by Andy Higgins.*)

This group were photographed in the 1950s and includes (left to right): Joan Bree, whose mother was Elizabeth Kelly, Sean Mc-Mahon, son of Garda McMahon who worked at Strandhill garda barracks, later the home of the Cosgrove family, and, fifth from left, Packie Foley, husband of Deirdre Foley, who died young. The Waverley Hotel, later called The Wolfhound, can be seen in the background, and, to the left, Benjamin Murrow's Buenos Ayres House behind its curved wall. The forestry has not yet been planted on the slopes of Knocknarea. (*Photograph kindly made available by Donald and Joan Bree.*)

Three Quinn sisters, originally from Carracastle, with their three daughters and three grand-daughters. The central sister, Catherine, married a Kelly from Carrowbunnaun and became the grandmother of Donald and Joan Bree of Larass. Behind her is her daughter Kathleen, seen in earlier school photographs as a young girl, and (hand on her shoulder) her granddaughter Catherine King. On the left is her sister Norah Carty, *née* Quinn, and on the right is Lizzie Quinn. Catherine lost her daughter Mary-Jane to meningitis at the age of thirteen. Another daughter, Elizabeth, married John Bree and was mother to Donald and Joan Bree. (*Information and photograph kindly made available by Donald and Joan Bree.*)

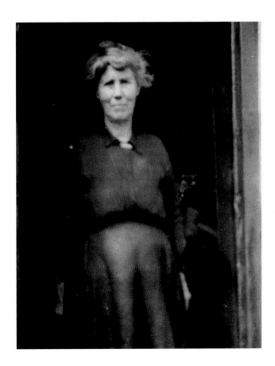

Katie Mannion, who was mother of Hanna Mannion, who ran a small grocery shop in the two-storey house to the left of the modern roundabout at the junction of the Top Road and Burma Road, until her death in 1992. (*Information and photograph kindly made available by Sean Mannion.*)

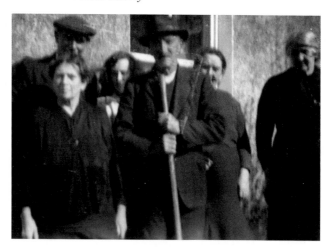

Katie Mannion (front) in old age and her husband Johnny, with daughter Hanna (centre back) pictured outside the two-storey Mannion house and shop in the 1930s. In the mid-nineteenth century, Johnny Mannion's father, Denis Mannion, ran a small pub in the shed that faced the gable of their house. This shebeen once extended to the middle of the road at Mannionstown, before the county council twice removed parts to widen the road. (*Information and photograph kindly made available by Sean Mannion.*)

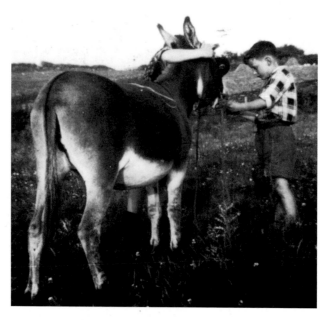

Sean Mannion, Mannionstown, with the family donkey in 1954. The donkey would be brought by Sean, then aged twelve, to Ballintogher to collect turf and home again. (*Information and photograph kindly made available by Sean Mannion.*)

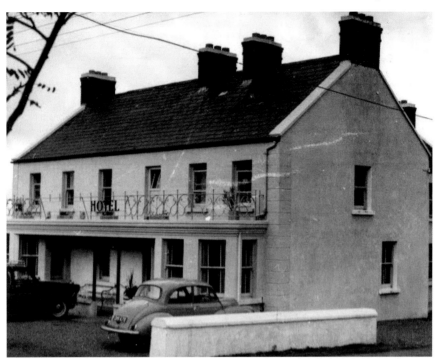

The Sancta Maria hotel, at the junction of the Top Road and Buenos Ayres Drive, pictured in the early 1960s. It was bought and run by Joe and Ita McMorrow from 1957, and became very popular for weddings, dances and Sunday lunches. The metalwork above the veranda originally bore the earlier name of the Central Hotel, which they changed to Sancta Maria. In the 1960s, they extended the bay windows at the left front and incorporated part of the veranda into the lounge. The postcard was printed by Kennelly Photoworks, Tralee, for the McMorrows, who had them distributed to promote the Sancta Maria. (*Information kindly made available by Ita McMorrow Leyden.*)

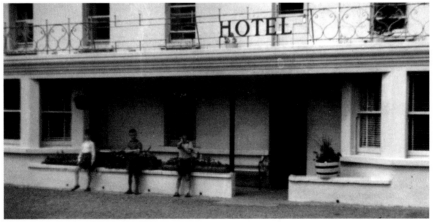

Some of the McMorrow children outside the hotel in the 1960s, before the name above the veranda was changed. (*Information and photograph kindly made available by Ita McMorrow Leyden.*)

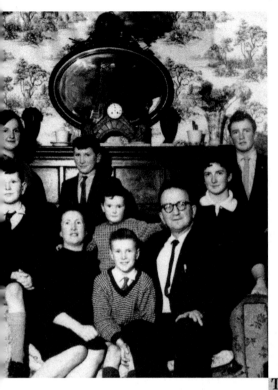

Joe and Ita McMorrow with their seven children pictured in the Sancta Maria lounge, in front of the fireplace that had come originally from the Phibbs mansion, Seafield House, at Lisheen. Ita McMorrow, *née* Horan, was from Lugnagall in Glencar. She co-founded, with Kathleen Parke, the Strandhill Guild of the ICA. She and Kathleen signed the contract to buy Dolly's Cottage for the ICA. (*Information and photograph kindly made available by Ita McMorrow Leyden.*)

Ita McMorrow was a noted cook. This article, published in *The Irish Press* in 1966, reports her winning the national ICA Seafood Cook Award for 1966, sponsored by Bord Iascaigh Mhara (BIM), the state fisheries board. The article goes on to recount BIM efforts to foster interest in fish cookery among Irish women. Up to then, fish was mainly eaten on Fridays by Roman Catholics who had to abstain from eating meat, and it was regarded by people as a form of penance. (*Article kindly made available by Ita McMorrow Leyden.*)

THE woman who has been chosen as Irish Countrywomen's Association Sea Food Cook for 1966 is a Sligo mother of seven children, who owns and runs a hotel in the seaside resort of Strandhill. And a daughter, Mary, follows in mother's footsteps in catering ability.

Mrs. Ita McMorrow, wife of Mr. Joe McMorrow, Court Clerk in Sligo and chairman of the Sligo County Board of the G.A.A. won her title and £50 prize at a two-day contest in the I.C.A. headquarters, An Grianán, Co. Louth.

Daughter Mary (21) took a diploma in institutional management at St. Mary's College of Domestic Science, Cathal Brugha Street, Dublin, and is now a school meals supervisor in Omagh.

The fish cookery contest was sponsored by Bord Iascaigh Mhara and each federation of I.C.A. sent on a winner picked at earlier contests.

"I have always felt that we in Ireland should eat more fish and I have always been interested in cooking and serving it," says Mrs. McMorrow, whose Sancta Maria Hotel overlooks the giant sweep of Atlantic that is Strandhill Bay.

Though Strandhill is right on the open ocean, no fish are landed there . . . apart from shellfish. There is no harbour and the massive breakers don't permit the safe use of small boats.

But Sligo, generally, is a good source of fish and Mrs. McMorrow finds no difficulty in getting supplies for the marvellous dishes she turns out.

The Bord Iascaigh Mhara — I.C.A. cookery contest, which started last year, has stimulated tremendous interest in fish cookery throughout the whole I.C.A. organisation.

Apart from the competitions Bord Iascaigh Mhara conducts an annual scholarship course in fish cookery for members of the I.C.A. More than 200 women have now taken part, taking home to their own guilds the knowledge they assimilate at the courses.

'We should eat more fish' – be sea food cook

fibres market because of its adaptability and very durable qualities.

They sell the fibre to the An Uaimh firm and the results of their work will be on show in a wide range or design. There will also be a film show on the development and uses of Agrilan.

EIGHTY AND STILL WRITES

A DONEGAL man in his late eighties has just had his second book published within a year . . . and he is still writing. He is Mr. Harry Swan, the well-known author, antiquarian and archaeologist of Buncrana.

Last July he had "Romantic Stories and Legends of Donegal" published. Now comes "Gems Of Wit and Wisdom," a 260-page work into which, he says, goes a condensation of a lifetime of research and recording.

Company director and businessman Mr. Swan, who is a former president of the Donegal Historical Society, has produced many works on the history of Donegal, many of them based on his researches as an archaeologist and antiquarian.

"I am still writing," he told

me, "and I intend to continue it. It is important that we record for posterity the history and legends of our land. Much of it has never been written down but carried down by the spoken word through the generations."

HOME FROM MISSIONS

HAVING a brief rest in Drogheda after some very extensive travelling is Rev. John Daly, C.S.Sp. A member of the Holy Ghost Mission in Nigeria, he has been to both sessions of the Vatican Council and en-route from Rome to Ireland spent 10 days in the Holy Land.

Father Daly has been in Africa for the past 22 years and is the new Rector of the Bigard Memorial Seminary, in Eastern Nigeria. It has 180 students and there were 18 ordinations there last year.

Father Daly's new appointment was announced last year but he has been unable to take up duty until now because of his Vatican Council duties. He travelled with the Nigerian Bishops as an expert on education and the theology of the missions.

He returns to Africa during

the coming of his Irish sister, Miss Street, Dro

SISTER ON H

HOLIDAY County nuns who a visit home Ireland fo M. Rosario, Estate Cou Queensland years ago; Nolasco, w Holy Famil ver, Towns 29 years. They are county cou Farrell, of Said Mot has been in Ireland almost umb Though i a long long says, the c near each sister lives from them a stone's t standards Sister Nola

WINDOW ON THE PAST

RESISTANCE to the Anglo-Norman power in late medieval Ireland was strong at the end of the fourteenth century and it was to subdue it

Leinstermen and his death was to cause confusion and war in Britain. The succession to the throne was now in dispute, or at least was to be so in the

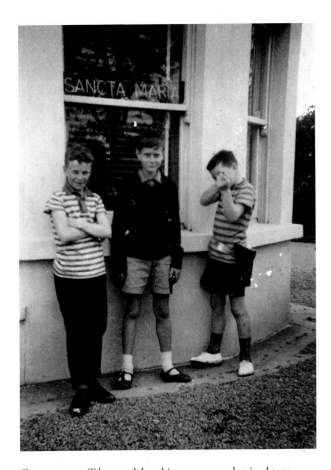

Short trousers, T-bar sandals, white runners and striped tops called a 'sloppy Joe' were commonly worn by young boys like the McMorrow children in the 1960s. A rifle or a revolver in a holster was a much-used toy. These lads were probably playing a game of cowboys and Indians. (*Photograph kindly made available by Ita McMorrow Leyden.*)

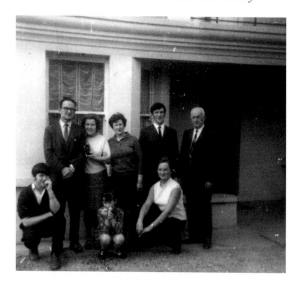

Members of the McMorrow family, including (back row, left) Joe and Ita Snr (third left) outside the Sancta Maria in the late 1960s. Second left is Kitty Cullen, Glencar, and right is Michael McMorrow, Carney. Front, left to right: Tony Morrow, Anne McMorrow and Ita McMorrow Jr. By this time, the veranda had been shortened and the bay windows extended. (*Photograph kindly made available by Ita McMorrow Leyden.*)

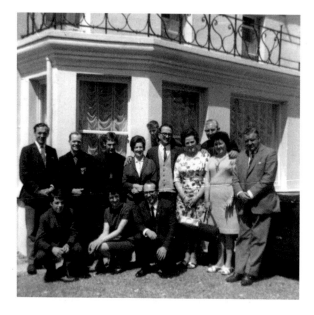

A group of Northern Ireland boxers, pictured with their families and Joe McMorrow (back row, fourth left). They had been boxing in the Baymount hotel on Buenos Ayres Drive and stayed in the Sancta Maria. (*Information and photograph kindly made available by Ita McMorrow Leyden.*)

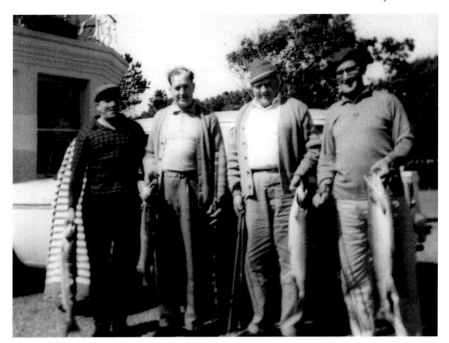

These Welsh fishermen stayed in the Sancta Maria in the 1960s, but they did not catch the fine salmon they are holding. Mrs McMorrow, who was an award-winning fish cook, gave them the salmon from the kitchen for the photos. (*Information and photograph kindly made available by Ita McMorrow Leyden.*)

Bernard (Barnie) Mannion outside his family home in Carnadough, with horse-and-cart going to collect water in the barrel. He used to collect water for general use from a pump in Carrowbunnaun, on the Top Road at the southern entrance to Strandhill. They got drinking water from the well at the commonage near their house in Carnadough. The horse, called Paddy, was let roam free on the mountain and was called when needed. (*Information and photograph kindly made available by the Mannion family.*)

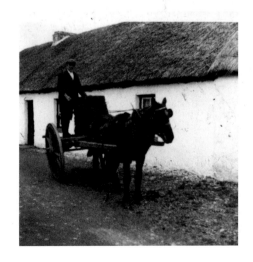

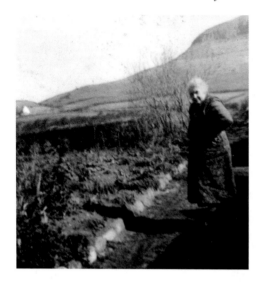

LEFT: Mary Mannion, wife of Barnie Mannion, in her vegetable garden in Carnadough in the 1940s. The garden was in a field just north of their thatched house. She was mother to Denis (Den), Michael (Mickey) and Kathleen Mannion (married name Devins). (*Information and photograph kindly made available by the Mannion family.*)

BELOW: Denis (Den) Mannion (far right), with a group at a race meeting in Culleenamore in 1957. Also in the group are (left to right): Thomas Foley, Tom Scanlon, who lived in a two-storey house beside the old Airport Road at Rinn that used to house a seaweed baths, Annie Joe Mannion and Packie Kennedy. (*Information and photograph kindly made available by the Mannion family.*)

Michael Mannion emigrated to the United States and returned on a visit in 1957. He is photographed outside the family home in Carnadough. (*Information and photograph kindly made available by the Mannion family.*)

Michael Mannion (centre) after saving oats in Carrowbunnaun, in a field between the golf club and the Catholic church, with Roddie Parke (left) and Padraig Duggan. There was a spring well in that field called Burrowhatch or Burrow Cait. (*Information and photograph kindly made available by the Mannion family.*)

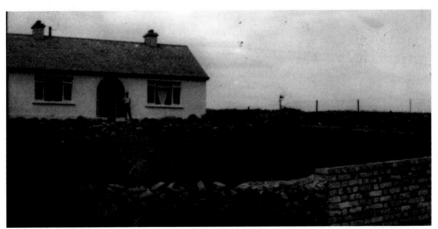

The Mannion family left their thatched house at Culleenamore beach and moved to a new house on the Top Road in 1959. This photograph shows the house before the garden or trees were planted. The curved brick wall at the front was built by Den Mannion with bricks that came from Seafield House, the former Phibbs family house, in Lisheen townland. (*Information and photograph kindly made available by the Mannion family.*)

6.
People and Faces

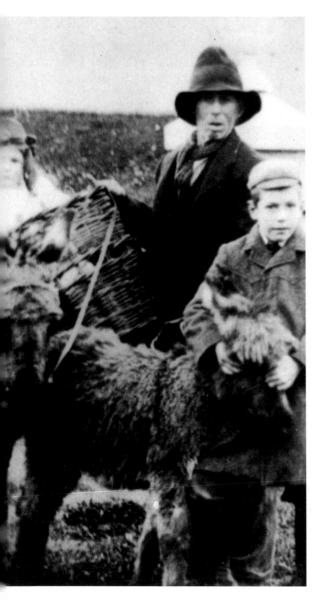

A 1902 picture of Pat Ward, with the children of Benjamin Murrow, at Buenos Ayres House. Pat had a horse and trap and he worked for Benjamin Murrow. He used to live in a house that stood beside the present Venue pub; a two-storey, red-brick house was later built on the site. He and his family were evicted by Benjamin Murrow because of difficult times, and they moved to live in a herd's house up on the side of Knocknarea, which became known as Ward's house. Relations between him and the Murrow family remained good. Ward's house is now a ruin. *(Information and photograph kindly made available by Andy Higgins.)*

Michael McLoughlin, who worked for Freeman Nuttall at Culleenamore, holding a horse's halter with foal alongside. He was deaf in one ear because a donkey bit it off. He and his brother, who was blind, lived in a thatched house beside the Mannion family at Culleenamore beach in Carnadough. The two thatched houses were rebuilt and slated in the 1960s by Den Mannion, and a two-storey house now stands on the site of the McLoughlin house. (*Photograph part of Nuttall collection and kindly made available by the Mannion family.*)

Thady Higgins (centre) with Jimmy 'Tickety-boo' Curran (left) and Ernie Carter on Buenos Ayres Drive. Thady Higgins had a donkey and creels, and he worked in the gardens of the Walker estate at Rathcarrick. He lived in a thatched house on Thady's Lane, now the Burma Road. At the time of this photograph, the road to the shore is still roughly surfaced and the three-storey Waverly Hotel can be seen in the background. The Waverley was built in 1914. From the 1970s on, it was called The Wolfhound and was run by Maggie Lagan. It burned down in the early 1990s and was demolished in 1993. (*Photograph kindly made available by Andy Higgins.*)

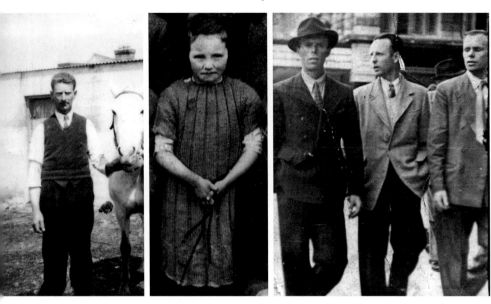

LEFT: Roddie Parke, Carrowbunnaun. He was a farmer and brother of Georgie Parke who bought Murrow's seaweed baths and the hotel that is now the Strand pub. (*Photograph kindly made available by Andy Higgins.*) CENTRE: Bridie Bree, of Bree's pub, Larass, as a young school-girl in 1924. She did not marry, and she and her brother Sonny ran the pub for many years. (*Photograph kindly made available by Donald and Joan Bree.*) RIGHT: Sonny Bree (centre), owner of Bree's pub and brother of Bridie Bree, with Harry Ward (left) and Johnny Ward. He died in June 2001. (*Photograph kindly made available by Andy Higgins.*)

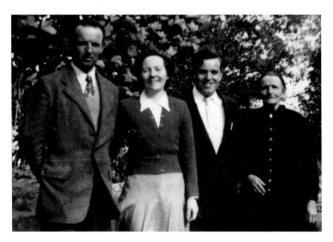

Bridie Bree (second left) in 1954, with Sonny (left), her mother Bridget (Beezie) and Tommy Foley. (*Photograph kindly made available by Donald and Joan Bree.*)

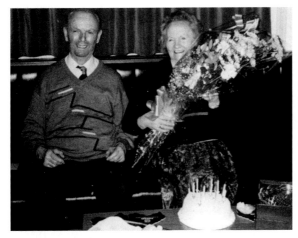

Bridie Bree, with her brother Sonny, in Bree's pub on her birthday in August 1994. (*Photograph kindly made available by Donald and Joan Bree.*)

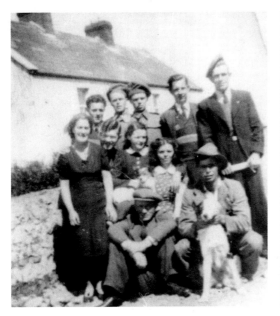

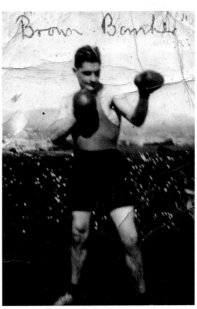

LEFT: The Venue pub was originally called Cole's and was built in the 1880s by Charles Cole. It was run by his children until 1979, when Kevin Flynn bought it, extended the building and called it The Venue. In this photograph, taken in 1941, are (front row, left to right): Sonny Mannion and P. Ward. Second row: Lily McSharry, J. Flynn, Rita Bree, K. Ward. Back row: T. Boyle, H. Daid, J. Ward, J, Kelly, C. Curran. The dog was called Caffer. Around this time, the owner of Cole's used to put a barrel and plank across the road to block people from going past his pub to the next pub, which was later called the Sancta Maria. Apartments now stand on the site of the garden behind the wall. (*Information and photograph kindly made available by Andy Higgins.*)

RIGHT: Paddy Conway, from Kilmacowen, was a well-known boxer who was called 'The Brown Bomber'. He used to box in England. He often went to Bree's pub at The Bridge in Larass. (*Photograph kindly made available by Andy Higgins.*)

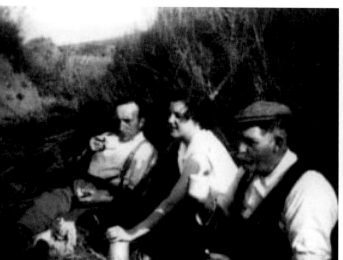
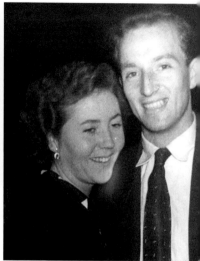

LEFT: Saving hay was hard work, and a cup of tea, often carried in a glass bottle or jug, was always welcome. Here, Cis Foley, The Bridge, is bringing tea to Joe Gilligan (left) from Lecarrow townland and her father Paddy Foley. Each year, in a field opposite Bree's pub in Larass, a contractor used to bring two threshing machines that threshed wheat, oats or barley for local farmers. Another threshing machine used to be located in a field beside the Top Road entrance to Buenos Ayres House, where there are now two bungalows. (*Information from Roy Kilfeather and photograph kindly made available by Andy Higgins.*)

RIGHT: Evelyn Murray, daughter of Francie Higgins and niece of Dolly Higgins, and Sean Byrne in the Silver Slipper in the 1950s. (*Photograph kindly made available by Andy Higgins.*)

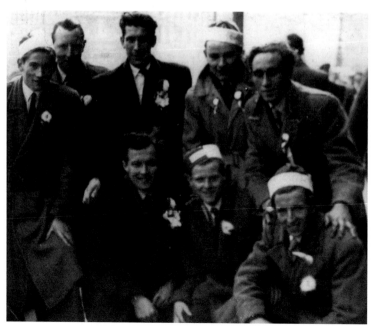

LEFT Strandhill Sligo Rovers fans on Sunday, 30 March 1952, at the cup semi-final match when Cork Athletic beat Rovers. Back row, left to right: Harry Carter, Sonny Kelly, Bob Murrow, Donald Bree and Denis Mannion. Front row: Patsy Byrne, Packie Foley and Sean Byrne. (*Photograph kindly made available by Donald and Joan Bree.*)

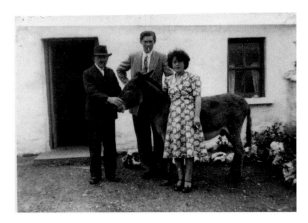

Thady Higgins (left), outside his house on the Burma Road, with Ernie Carter, Mary Kate Higgins and Jack, the ass. Mary Kate Higgins worked in the cloakroom of the Silver Slipper. Thady used to bring apples in donkey creels from the Walker orchards and give them to everybody at The Bridge. (*Information and photograph kindly made available by Andy Higgins.*)

Farmer Paddy Dolan, who lived in the first house on The Line. He and his wife were from County Leitrim but settled in Strandhill, and they worked a subsistence farm there while he also worked as a full-time van driver for Denny's bacon factory in Sligo. He got one of his fields after the Land Commission acquired and redistributed the lands of the Meredith estate in the 1960s. His wife did a lot of the farming work in his place, taking care of feeding livestock and chickens, and milking cows, while making their own butter and baking their bread. (*Information and photograph kindly made available by Brid Dolan.*)

7.
Two Parishes

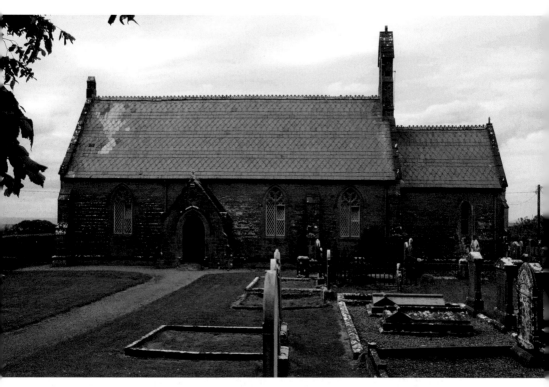

St Anne's Church of Ireland church in Tully before its restoration in 2011. The church was completed in 1845, after some years of fundraising. It was built because it was too far for people to walk to the nearest churches in Sligo or Ballisodare, and because the Strandhill parishioners were conscious of the contrast between 'their rustic garb [and] that of the better clad citizens' of those churches. The Collooney-born architect John Benson, who designed the buildings for the Irish Industrial Exhibition in Dublin in 1852, designed St Anne's. He was a kinsman of the Benson family, including Maisie Benson of Ballymote. He became the city and county engineer in Cork, and designed its quays and English Market. (*Photograph taken by Hugh MacConville and kindly made available by the parish of St Anne.*)

PARISH OF KNOCKNAREA.
CHURCH OF ST. ANNE.

SUCCESSION OF CLERGY.

St. Bronus. (Bishop).	450.
St. Biteus. (Bishop).	511.
Peter O'Tuathalain.	1306.
William Newport. B.A.	1633-1635.
John Wilkinson. M.A.	1666-1681.
Coote Ormsby. B.D.	1681-1694.
John Fontanier. M.A.	1694-1730.
Eubule Ormsby. M.A.	1730-1771.
Manly Gore. M.A.	1771-1776.
Wensly Bond. M.A. D.D.	1776-1822.
Charles Hamilton. B.A.	1822-1843.
James Gulley. M.A.	1843-1861.
John W. Chambers. B.A. LL.D.	1861-1864.
Charles H. Hamilton. B.A. B.D.	1864-1867.
William A. Day. B.A.	1867-1877.
Isaac Coulter. M.A. D.D.	1877-1881.
Frederic J. Hamilton. B.A. D.D.	1881-1884.
John Galbraith. B.A.	1884-1892.
Richard W. Landey.	1893-1916.
F.W.E. Wagner. M.A. D.D. Sc.D.	1916-1926.
W. Popham Hosford	1926 -1946.
C. C. W. Browne, B.D.	1947 -1983.
H. S. Mortimer, M.A.	1983 -1991.

St Anne's is in the Church of Ireland parish of Knocknarea. It has a continuous record of the clergy of the parish back to the seventeenth century, with links to the pre-Reformation Christian foundation at Killaspugbrone. Peter O Tuathaláin, who is recorded in this list, which is held in the church, was vicar of Killaspugbrone, and his death in 1306 is noted in the record of medieval Ireland, the *Annals of the Four Masters*. The tenure of post-Reformation clergy starts with William Newport in 1633. A Revd Rogers, and his wife Annette (*née* Nesbit) and son, also lived in the rectory for two years after the tenure of W. Popham Hosford. (*Information from Kathleen Devins and document kindly made available by the parish of St Anne.*)

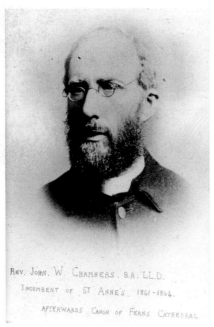

LEFT: The Revd John W. Chambers is the first incumbent of St Anne's for whom there is a photograph. He served in the parish from 1861 to 1864 and then became canon of Ferns Cathedral in Wexford. (*Photograph kindly made available by the parish of St Anne.*)
RIGHT: The interior of St Anne's church, facing east, photographed on 9 May 1917. The three-bay, stained-glass window depicts biblical scenes. (*Photograph kindly made available by the parish of St Anne.*)

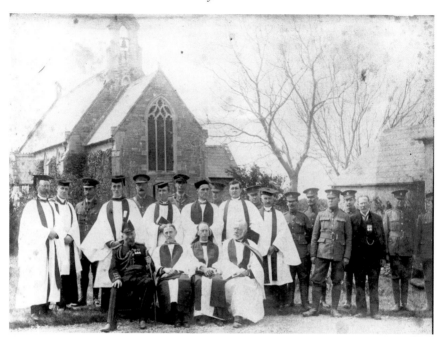

On 9 May 1917, Col. William Gregory Wood-Martin, an *aide-de-camp* to three British monarchs, a pioneer of Irish archaeology, and a respected writer on the monuments and customs of ancient Ireland, dedicated memorials in St Anne's to two of his sons, James and Francis, who were killed in France in the First World War. He is seen here after the unveiling seated outside St Anne's with (front row, from left): the Ven. W. Wagner, Archdeacon of Elphin, the Revd B.J. Plunket, Bishop of Tuam, and the Ven. W.E. Colvin, Archdeacon of Killala. Second row: Revd F.W. Wagner, rector of St Anne's, Revd Canon Ardill, Ven. G.F. McCormick, Archdeacon of Achonry, Revd J. Allen, and Revd W.F. Nunan. Back row: Revd J.L. Poë, Revd W.L. Shade, Major Murphy, Colonel Chamier, Lieutenant Draper, and unnamed NCOs of the Connaught Rangers. Col. Wood-Martin died later in 1917. (*Photograph kindly made available by Richard Wood-Martin.*)

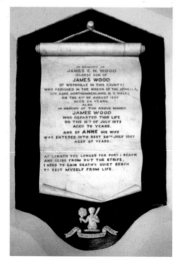

St Anne's church contains many memorials to parish members, some of whom lost their lives in tragic circumstances. This plaque records the death, in August 1859, of James Edmond Wood of Woodville House, who died aged twenty-four, when his ship, the *Admella*, was wrecked off the coast of New South Wales, Australia. He was the eldest son of James Wood of Woodville House. James Wood's second wife was Anne Martin, and on his death in 1873 she joined his family name to hers. Their son was William Gregory Wood-Martin.

The simple words of this memorial carry great sadness as they record the death of Alured Ventry Phibbs, lost at sea at the age of just seventeen in 1895. Although it is not stated, it is very likely he was the son of Owen Phibbs (1842-1914) of Seafield House, Lisheen, and his wife Susan Talbot-Crosbie.

ALURED VENTRY PHIBBS.

LOST AT SEA
19TH SEPTEMBER 1895.
AGED 17 YEARS.

"And the sea gave up the dead which were in it."

William Griffith Phibbs was forty-two when he died 'of pneumonia contracted in the trenches' while serving with the Royal Irish Fusiliers in the First World War. He was the son of George Griffith Phibbs and nephew of Owen Phibbs of Seafield House.

TO THE MEMORY
OF
WILLIAM GRIFFITH PHIBBS.
MAJOR 1ST BATT. PRINCESS VICTORIA'S
ROYAL IRISH FUSILIERS.
ONLY SON OF THE LATE
LT. COL. GEORGE GRIFFITH PHIBBS.
DIED ON NOVR. 8TH. 1914.
OF PNEUMONIA CONTRACTED IN THE
TRENCHES.
AGED 42 YEARS.
"Dulce et decorum est pro patriâ mori."
THIS TABLET IS ERECTED BY HIS WIFE.

The nave of St Anne's as it is today. Very little has changed since 1917, but the pulpit and the sign announcing the numbers of hymns appear to have switched places to the opposite sides of the aisle. (*Photograph taken by Hugh MacConville and kindly made available by the parish of St Anne.*)

The elaborately carved baptismal font, which dates to 1854, depicts foliage, angels and figures representing the Four Evangelists, the writers of the four Gospels of the biblical New Testament. (*Photograph taken by Hugh MacConville and kindly made available by the parish of St Anne.*)

The timber roof trusses in the ceiling are ornately carved in gothic style. (*Photograph taken by Hugh MacConville and kindly made available by the parish of St Anne.*)

In 2011, restoration work on the roof and interior was carried out while retaining the original blue Bangor slates, decorative ridge tiles and diamond-shaped patterned tiling. The roof was repaired by Justin Harte, a local roofer and stone mason. When first built, limestone for St Anne's construction came from Clarence's quarry, Ballisodare. (*Photograph taken by Hugh MacConville and kindly made available by the parish of St Anne.*)

The corbels or projecting roof supports on the inside walls appear to rest on blue and gold-painted angels. (*Photograph taken by Hugh MacConville and kindly made available by the parish of St Anne.*)

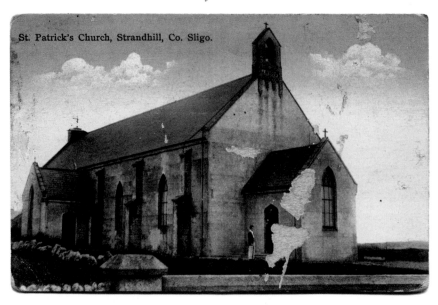

St Patrick's Catholic church built on the site that was donated by Benjamin Murrow. Started in 1920, it was completed in June 1921. The picture was taken after 1934, when the concrete wall around the church was built. Before, Catholics from Strandhill had to travel to the old church in Knocknarea for religious services. When the foundations were being dug, signs of an early house were found eight foot down in the sand. Oral history recounts that the road from Carnadough, now the Golf Links road, was lined with several thatched houses that were buried in sand by the Big Wind of 1839. (*Postcard kindly made available by the Mannion family.*)

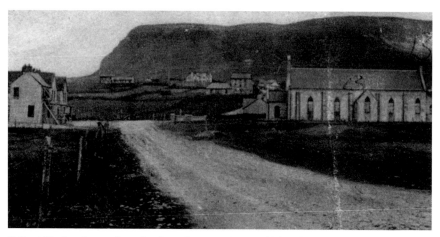

St Patrick's church seen from the shore direction. St Patrick's hotel, where building work is going on, can be seen on the left. This hotel, later called The Kincora, was built in 1922, so the photograph was taken then, which was one year after the church was completed. A cement casket was placed in the sacristy with details of the building date, samples of Irish coins of the time and Sligo newspapers. The dedication ceremony was attended by the Bishops of Elphin, Achonry and Clonfert, Drs Coyne, Morrisroe and O'Doherty. Fr Mulligan was the curate responsible for Strandhill at this time. (*Photograph kindly made available by Andy Higgins.*)

ABOVE LEFT: Fr Thomas Moran, who was also a captain of Strandhill Golf Club in the late 1940s and its president from 1956 to 1965. The earliest recorded priests serving the parish of Killaspugbrone, to which Strandhill used to belong, were: Fathers Owen Mihan (or Meehan) in 1698, John Dugan in 1704 (who was ordained in 1673 at Ashleage, County Galway, by Dom Bourk, Bishop of Elphin), John McDonagh, of whom there are no details, Fr Mac Dermott, who said Mass 'in the fields at Drynahan', and Fr David Flynn in 1743. (*Photograph kindly made available by Strandhill Golf Club.*)

ABOVE RIGHT: Fr Liam Devine, who served as priest in the 1980s. He was followed by Fr Dominic Gillooly, who was the first priest to occupy the presbytery on the Golf Links road. (*Photograph kindly made available by Strandhill Guild, ICA.*)

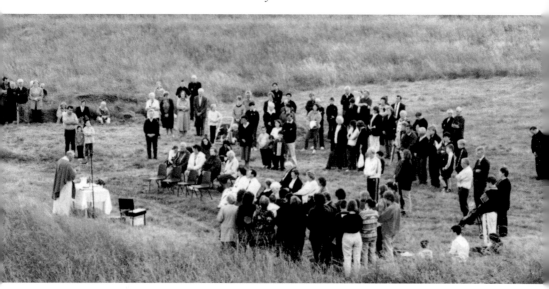

Since the 1990s, a memorial Mass has been said each year close to Killaspugbrone to remember those buried in the graveyard. Fr Creaton, who was first to be appointed parish priest of St Patrick's, is seen here celebrating Mass in 2003. (*Photograph kindly made available by Andy Higgins.*)

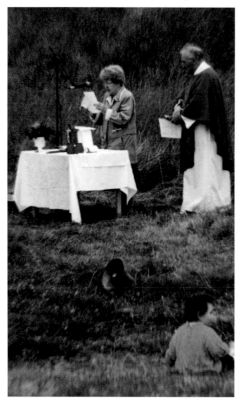

Evelyn Murray and Fr Creaton, celebrant, at the 2003 annual Mass in memory of people buried in Killaspugbrone graveyard. (*Photograph kindly made available by Andy Higgins.*)

Members of St Patrick's parish council taken in the late 1980s. Front row, left to right: Deirdre Foley, Fr Gillooly, Annie-Joe Mannion, Brian Duffy, Ann Taylor and John McGowan. Back row: Sean McHugh, Fr Devine, Don Bree, Manus Shields, Sean Mannion, John Keane and Martin Cronin. This may have been taken on the occasion when Fr Liam Devine replaced Fr Dominic Gillooly as priest at Strandhill. (*Photograph kindly made available by Hugh MacConville.*)

The interior of St Patrick's church, *c.*2000. The interior was painted in the late 1960s or early 1970s by local painter Paddy McLoughlin. (*Photograph kindly made available by Fr Frank O'Beirne, author of* History of Elphin Diocese *(2000).*)

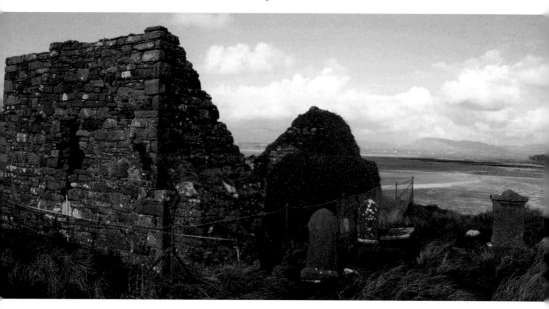

The present Killaspugbrone church, which dates from around the twelfth century, is probably the latest in a number of churches on the site that was first selected by St Patrick. The earlier buildings were probably thatched and the *caiseal* or circular stone enclosure within which they were built may have been older. It was built by St Patrick's disciple Brónus, who lived in Coolera and died in AD 511. The church is named *Cill Easpaig Brón*, the church of Bishop Brón. The *Fiacal Padraig* or St Patrick's Tooth Shrine was made for Thomas de Birmingham, Lord of Athenry, who owned the Killaspugbrone land in the fourteenth century, to contain a tooth lost by St Patrick near the site. (*Photograph kindly made available by Hugh MacConville.*)

ABOVE LEFT: The west end of Killaspugbrone church, where the original gable was built up with the addition of a late medieval three-storey tower. A vaulted room at ground level was used for storage (bottom centre). The priest's living space was above that and his bedroom was on the next floor. The tower was later removed. In the nineteenth century, the gentry Ormsby family had a burial vault built in the chamber at the base. In his will, made in 1733, Adam Ormsby asked to be buried 'privately' at Killaspugbrone. During the War of Independence in the 1920s, members of the IRA hid in the crypt and they used to come up to Mannion's house near The Line at night-time for food. (*Photograph kindly made available by Hugh MacConville.*) ABOVE RIGHT: The rounded Romanesque window in the eastern gable, which is outlined with finely shaped stonework. Below it is the stone altar, facing east according to Christian tradition. (*Photograph kindly made available by Hugh MacConville.*)

Early Christian church sites were usually set within a circular enclosure, either of stone or clay banks and ditches. At Killaspugbrone, an earthen bank and an external ditch, and sometimes two banks, run east to west for about 200m across the headland. The banks are about one metre high and eight metres wide. Because of shifting sands, it is hard to tell sometimes what is accumulated sand and what is man-made, and parts of the ditch have filled up. In this picture, the two banks and the ditch can be seen by the position of the people standing at them. (*Information provided by Cormac MacConville and photograph kindly made available by Hugh MacConville.*)

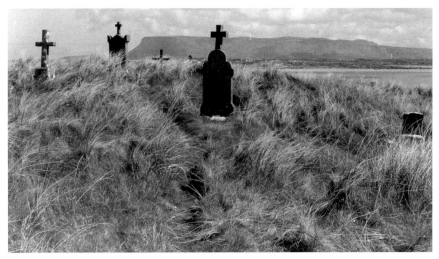

Gravestones in Killaspugbrone cemetery. Many families could not afford a carved headstone and used a flat stone to mark the graves, a common practice in very old graveyards. People brought coffins along Rinn shore for burial at Killaspugbrone. The Walker estate owned the land around the church, which was reached through what was called 'the red gate'. A local committee asked the landlord to leave the gate open so coffins could be brought through. He agreed on condition people manned the gate and closed it afterwards. Martin Bree, uncle of Donald and Joan Bree, manned the gate at times. The multi-denominational graveyard holds about 700 graves. The small beach to the left of the graveyard is called Traw Wan and a roar from the sea heard from here is a sign that frost is coming. The beach to the right is called Nuns' Bay. (*Photograph kindly made available by Hugh MacConville.*)

Registry of Interments in the ____ Cemetery, pursuant to 19th and 20th Vic., cap. 98.

Killaspugbrone graveyard was used for many centuries. Church of Ireland and Catholic parishes at different times from the eighteenth century onward kept a register of burials in parish graveyards. The Local Government Act (1898) made local authorities the 'sanitary authorities' responsible for keeping records of burials, and they had to be notified of all burials. This is the last page of the last register of burials for Killaspugbrone graveyard. The last burial registered was that of Sarah Parke, aged eighty-four, of Carrowbunnaun, who was buried on 20 November 1962. (*Access to register kindly made available by Sligo County Council.*)

ABOVE LEFT: The last registrar of burials at Killaspugbrone was John Bree of The Bridge, Larass, who died in August 1973 aged seventy-three. He is seen here in June 1973 in front of the original wall of the Bree family home, which had been a thatched house at the junction of The Line and the main road. On his death, the family returned the register to Sligo County Council. When making enquiries for this book, it was located in the office of the Infrastructure section of Sligo County Council. (*Information and photograph kindly made available by Donald and Joan Bree.*) ABOVE RIGHT: In 2007, the local Killaspugbrone Preservation Society erected a sign at the seafront to promote public knowledge of Killaspugbrone and its history. (*Photograph kindly made available by Hugh MacConville.*)

8.
School and Pupils

The old national school building on the Top Road, Carrowbunnaun. The first school in Strandhill was run by Laurence Ballantine in a one-roomed, thatched building in Larass from 1843. In 1896, it was replaced by this stone building at a cost of £200, plus £45 for the surrounding walls. The principal in 1896 was Kate Gallagher. (*Photograph kindly made available by Scoil Asicus Naofa.*)

Compositions 7 · 3 · 38
Old Schools

Day school was held where Knocknarea Hotel is now and night school in Strandhill Post Office. The pupils were taught indoors. The name of the teacher who taught in these schools was Larry Ballantine. He was not a stranger. Relatives of his are still living in Sligo. The teacher did not lodge in the farmers houses. He was paid six a week for each pupil if they attended day and night school. Irish was not spoken by the pupil or by the teacher. The master was trying to do away with Irish culture. Writing was done by a quill and by slate and pencil. The children were seated on stools. There was no blackboard but there was large sheets of paper hung on the wall. Larry Ballantine was the last hedge school master before the

National School commenced in this village of Strandhill Co. Sligo.
Told to Michael Molony by Jas Howley Culleenamore Sligo.

ABOVE LEFT: In 1938, children in 500 primary schools around the country were encouraged to collect folklore and history from older people in their home areas. Stories, riddles, cures, songs, games, customs, work skills, oral memory and local history were all documented in school copybooks by young pupils, including in Strandhill. In this essay, Michael Molony recorded James Howley's account of the old school in Strandhill, some of which he may have experienced himself or heard from his parents, depending on James Howley's age at the time. (*The Schools' Collection, Volume 0159, p.14, 1937–1938.*)

ABOVE RIGHT: The second page of Michael Molony's record of the old school in Larass, which he learned from talking to James Howley of Culleenamore. (*The Schools' Collection, Volume 0159, p.14, 1937–1938*)

				First Standard			
0	7·11	8·10	255	Patrick Ward			R.C.
0	6·23	7·3	260	Charles Kelly			"
0	6·23	8·1	271	Thomas J. Burns			"
0	6·23	6·3	270	Michael Bree			"
0	9·23	7	282	Eugenne McCarthy			"
0	9·23	8	277	Aloysius Martijn			"
0	7·11	10·3	285	Delia K. Gillen			R.C.
0	7·22	10·3	295	Annie Gillen			"
0	6·23	6·3	296	Kathleen Kelly			"

The earliest record of pupils in the school rolls in Strandhill school, written on 20 September 1872, although the starting date on the roll book itself is stated to be 1878. The columns note (from left to right) the number of absent days, the date of the pupil's admission to the class standard, the pupil's age in years and months, and their number on the school register. This roll was taken in the small school in Larass and the teacher at the time was Kate Sweeney, who herself became principal in 1872. (*Roll books kindly made available by Scoil Asicus Naofa.*)

ABOVE LEFT: On 20 September 1872, the district inspector visited the Larass school and wrote in the roll book that all the infants bar one had failed in knowledge of the alphabet, arithmetic in the first class was deficient, and the accounts for September were confused and unintelligible. Kate Sweeney had probably just become principal, as the inspector wrote that the teacher would have to 'exert herself to raise the proficiency of the school which has sunk very low'. A final note requires the teacher to enter up the first page of the new daily report book. (*Roll books kindly made available by Scoil Asicus Naofa.*)

ABOVE RIGHT: The head inspector, on a visit in 1887, found the 'room was kept very neatly'. However, the simplicity of the building can be gauged by his 'hope that the floor will ultimately be boarded'. (*Roll books kindly made available by Scoil Asicus Naofa.*)

The roll book dating between 1917 to 1923 gives an extract from the Irish Education Act of 1893, which laid down the rules for compulsory education. We can get a sense of children's lives at the time from section 3, which deems it a reasonable excuse for non-attendance that the child might be 'engaged in necessary operations of husbandry and the ingathering of crops, or giving assistance in the fisheries, or other work requiring to be done at a particular time or season'. A child under eleven could not be taken into employment 'except for the setting or planting potatoes, haymaking, or harvesting'. (*Roll books kindly made available by Scoil Asicus Naofa.*)

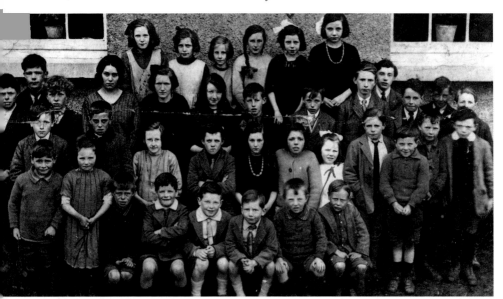

School group photograph taken in 1924 at the old National School on the Top Road. Front row, left to right: F. Higgins, Bridie Bree, P. Ward, A. Martin, Joe McCarthy, Jimmy McCarthy, Sonny Kelly, Jim Gray. Second row: M.J. Mannion, J. Howley, A. McLoughlin, T. Boyle, T. McNally, Delia Gillen, Kathleen Kelly, D. Byrne, J. Howley, J. Kelly, T.J. Burns. Third row: Packie Ward, T. Gillen, J. Curran, M. Martin, Kathleen Gillen, L. Gilmartin, J. Gilmartin, J.F. Mannion, R. Parke, J. Byrne, G. Byrne, T. Gilmartin, J. Gillen. Back row: M. Gillen, A. Gillen, M. McLoughlin, J. McNally, Mary Jane Kelly (who died of meningitis aged thirteen, and sister of Elizabeth Kelly, who married John Bree and was mother of Donald and Joan Bree). Bridie Bree, front row, ran Bree's pub with her brother Sonny until the 1990s. (*Information and photograph kindly made available by Donald and Joan Bree.*)

Story 11. ?. 38

Once Jimmy Howley was coming home at twelve o' clock at night. He heard a gallop of a horse behind. It came from the direction of a forth near by. The horse walked by his left side Jimmy nearly fell from weakness. He blessed himself. When he did the horse went on before him. It went up across the fields When he was going home at the back of the house he lost his hat. The fairies came on horses from Tireragh direction bearing candles. The light showed Jimmy his hat. The fairy host disappeared over Knocknarea.

Another story from Jimmy Howley in Strandhill recorded in the Schools Collection, in which he tells of meeting the fairy host coming from Tireragh on horseback at midnight bearing candles, whose light showed Jimmy where his lost hat was. The fairy host disappeared over Knocknarea. The clear handwriting shows the standard expected of young children at the time. (*The Schools' Collection, Volume 0159, p.14, 1937–1938*)

Following Irish independence, the Irish language became a subject in all schools, and progress was monitored by school inspectors, like other subjects. In May 1937, the *cigire*, or inspector, C.S. Ó Tuairisc commented in Irish in his report that the deputy teacher, Margaret McCarrick (Peggy Kelly), had proven able to bring an improvement to her portion of the school and was doing effective work. The pupils were industrious, well behaved and a Gaelic spirit was being fostered. It is typed using an Irish typeface and alphabet, with a séimhiú or dot over letters to be softened, instead of the modern 'h'. (*Roll books kindly made available by Scoil Asicus Naofa.*)

A school group photograph taken in 1949, with (left) the assistant teacher Peggy Kelly and (back right) principal Mary Kate Maguire. Mary Maguire taught the older pupils and Peggy Kelly the younger classes. The group includes: (front row, third left) John Curran, Buenos Ayres Drive; (third row, second left) Ken Huggard, now in New Zealand, whose family ran what later became The Dunes pub; and (fourth row, from left) Clare McLoughlin, Bridie Mannion, Mary Curran (holding child), Colette Flanagan, and (first right) Joe Bree. Back row: (second left) Seamus McMahon, (third) Paddy Mannion, (fourth) Denis Mannion, Mannionstown. (*Information and photograph kindly made available Roy Kilfeather.*)

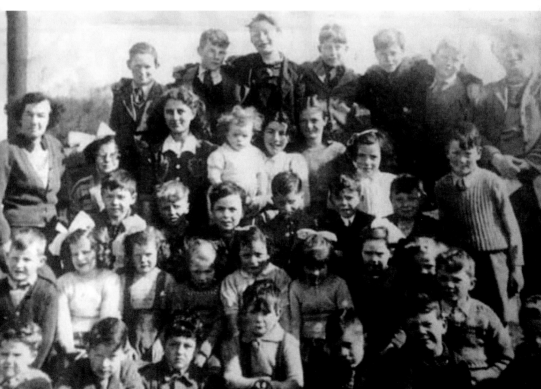

ᵹaeilᵹe

200 Marc. Am—Uair ᵹo leir.

Moltar timpeall 50 nóiméad a tabairt do Ceist 1, aᵹus timpeall 40 nóiméad do Ceist 2.

1965

1. Scríob aiste (ᵹan dul tar leatanac) ar ceann amáin de na hábair seo:

(a) Oíce Samna i do teac féin.

(b) Seanmála scoile aᵹ imint a scéil.

(c) An oíce a bris an ᵹadaí isteac i do teac.

(d) Lá an Aonaiᵹ, nó an lá a osclaíod an scoil nua.

(e) Marsiod an madra a bí mar peata aᵹat. Scríob litir cuiᵹ do cara aᵹ cur síos ar ᵹac rud a tarla.

2. Léiᵹ ᵹo cúramac an píosa seo a leanas aᵹus ansin freaᵹair na ceisteanna atá iná diaid.

(Nóta.—Ní ᵹá na ceisteanna féin a scríob amac; scríob uimir ᵹac ceiste díob roim an bfreaᵹra. Ní ᵹá freaᵹraí fada.)

I.—Ba ᵹrám liom beit aᵹ cuimneam ar an scoil. Ní raib aon taití (cleactad) aᵹam riam ar leanaí eile, aᵹus bí eaᵹla orm dul i measc scata mór de ᵹarsúin straingéarta. Ceap mé ᵹo mbead saol breá aᵹam dá bfeádpainn leanúint i m'aonar mar a bínn ᵹo dtí seo aᵹ lorg neadaca éan, aᵹ imirt sa srutáinín ar taob an bótair aᵹus aᵹ féacaint amac ar na sléibte ó fuinneoᵹ na cistine.

II.—Bí mé seact mbliana d'aois nuair a cuiread ar scoil mé. M'aintín a bí m éineact liom an céad maidin sin. Bí Risteard, mac an tsiúinéara, aᵹ fanact linn in aice a tí féim. Bí Risteard trí ráite níos sine ná mé féin aᵹus bí sé aᵹ dul ar scoil le dá bliain. D'imíomar linn, an triúr aᵹainn, aᵹus Risteard aᵹ síorcúr cainte ormsa.

47

LEFT: The Primary Certificate exam came at the end of primary school and helped determine a child's class in secondary school, if their parents could afford to send them. This exam in Irish, from 1965, is an example of what pupils doing the Primary Certificate had to pass. The old Irish typeface, alphabet and séimhiú are still being used. (*Book kindly made available by Scoil Asicus Naofa.*)

BELOW: Parents who wanted their children to have a secondary education had to pay fees until free second-level education was introduced in 1966. Before that, a child could sit an exam for a scholarship, often from the county council, to pay for their secondary education. These are sample scholarship arithmetic exam papers from 1961 and 1962. Imperial or pre-decimal measures of money, distance and weight are still in use. Money is expressed in pounds, shillings and pence, and weight is measured in pounds and tons. (*Book kindly made available by Scoil Asicus Naofa.*)

6 SCHOLARSHIP PAPERS

8. A certain alloy is composed of zinc, tin, and lead. The weight of the zinc is $\frac{3}{4}$ that of the tin, and the weight of the tin is $\frac{5}{6}$ that of the lead. Find in pounds the weight of the tin in 1 cwt. of the alloy.

1962

Candidates should answer all the questions, which are of equal value.

SECTION A

1. Multiply £8 8s. 2$\frac{1}{4}$d. by 9$\frac{9}{17}$.

2. Write 5 cwts. 3 qrs. 7 lbs. as a decimal of 5 tons.

3. Find, correct to the nearest penny, the simple interest on £550 14s. for 3 years at 6$\frac{3}{4}$% per annum.

4. During a year a hotel manager buys 30 tons of coal at £8 15s. per ton, 25 tons at £9 5s. per ton, and 25 tons at £9 12s. per ton. Find the average price of the coal per ton.

SECTION B

5. A man makes 20% profit by selling a motor car for £186. What selling price would give him a profit of 30%?

6. A farm is divided into three parts. If the first part contains $\frac{2}{9}$ of the total, the second part ·625 of the remainder, and the other part 34 acres 3 rds. 29 sq. per., find the area of the farm.

7. Three brothers paid a bill between them. If their payments were proportional to 7, 5, and 9, and the first two together paid £117 5s. 4d., find the average payment of the three.

8. A rectangular room is 12 ft. 6 ins. long and 11 ft. high. The area of the four walls is 506 sq. ft. What would it cost to carpet the floor of the room at 27s. 6d. per square yard?

ARITHMETIC 7

1961

Candidates should answer *all* the questions in Section A, and not more than *three* questions in Section B.

NOTE: *These instructions apply also to the papers for 1960—1957, inclusive.*

SECTION A

1. Simplify: $\dfrac{\frac{1}{3}(\frac{1}{2}+\frac{1}{4})}{\frac{1}{4}(\frac{1}{3}+\frac{1}{4})} \div \dfrac{3\frac{1}{2}-\frac{3}{8}\times 2\frac{2}{3}}{3\frac{1}{2}\div\frac{1}{3}-2\frac{2}{3}}$.

2. Find, to the nearest shilling, the cost of repairing a road 2 miles 7 furlongs 25 perches long at £77 18s. 4d. per mile.

3. What rate per cent of simple interest would be required in order that £275 should grow to an amount of £333 8s. 9d. in five years?

4. A man who takes 7 steps in three seconds walks 6$\frac{1}{4}$ kilometres in an hour. Find, to the nearest centimetre, the length of his step.

5. The average daily rainfall in a certain district for the month of December was 1·38 inches. Excluding Christmas Day, the average daily rainfall was 1·39 inches. How many inches of rain fell on Christmas Day?

SECTION B

6. A person has £2 10s. 6$\frac{1}{4}$d. in pennies and halfpennies, and the numbers of halfpennies exceeds the number of pennies by 34. How many of each kind has he?

[30 marks.]

Scholarship exam papers were sold in booklets so pupils could practise sample questions. A schoolboy, Gerard Taheny, scribbled his calculations on the inside cover of his book and then his mind wandered from his work, and he wrote, 'I think Bonny is absolutely nuts.' (*Book kindly made available by Scoil Asicus Naofa.*)

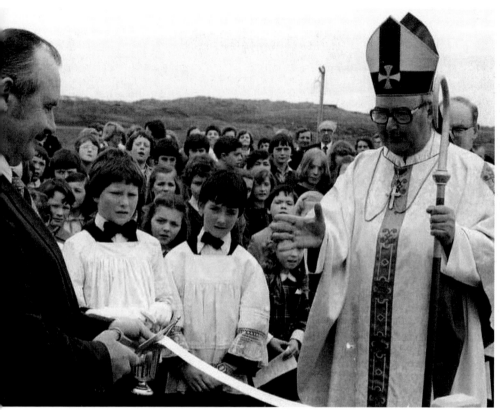

The old stone school building was replaced in 1981 by a new school built on a site on the Golf Links road. The site was donated by Victoria Jenet, who lived at Culleenamore. The school was formally opened on 2 April 1981 by Bishop of Elphin Dominic Conway (seen here) assisted by Fr Dominic Gillooley and Fr Travers. (*Photograph kindly made available by Scoil Asicus Naofa.*)

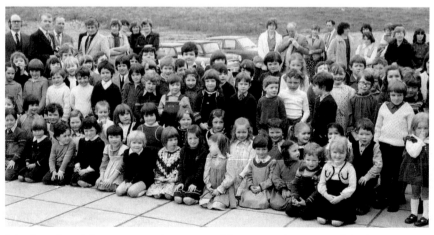

School pupils and their parents at the opening of the new Scoil Asicus Naofa building in 1981. (*Photograph kindly made available by Scoil Asicus Naofa.*)

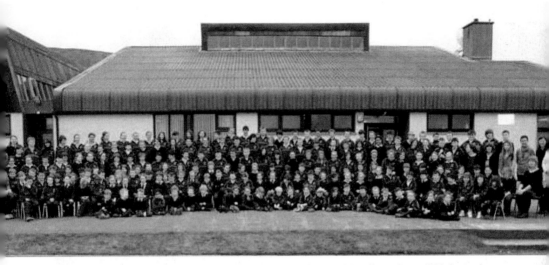

The new school building and its pupils and teachers. (*Photograph kindly made available by Scoil Asicus Naofa.*)

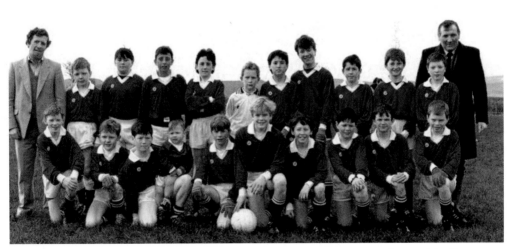

The school football team in 1990 with the principal Manus Shields (right). (*Photograph kindly made available by Scoil Asicus Naofa.*)

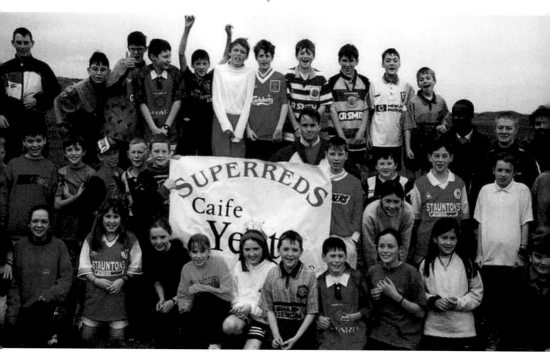

Some of Sligo Rovers football squad (right) paid a visit to the school in 1996. (*Photograph kindly made available by Scoil Asicus Naofa.*)

The former national school was used as a community space for some years and was then out of use for some time. In 2015, most of the building was demolished, keeping only the walls and roof, and it was rebuilt as a private house.

9.
Events and Sports

On 6 January 1839, the 'Big Wind' roared over Ireland, destroying houses, killing people and animals, sinking ships and flattening crops. The events of that night were kept alive in popular memory. In 1939, Strandhill schoolboy Michael Molony recorded James Howley's account of that event for the national schools' folklore project, in which pupils gathered older people's recollections of times past. In this essay he writes of the damage the Big Wind did in Carrow-bunnaun. When foundations were dug for St Patrick's church in 1920, the remains of a house were found buried eight feet down under sand. (*The Schools' Collection, Volume 0159, p.14, 1937–1938*)

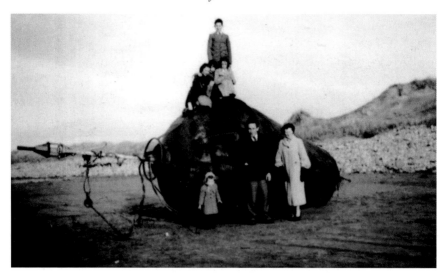

A large buoy floated onto Strandhill beach some time in the 1950s, attracting sightseers like this family. (*Photograph kindly made available by the Mannion family.*)

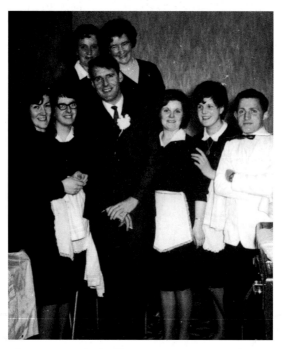

Maisie McDaniel, a superstar of Ireland's country music scene in the 1960s, married fellow musician Fintan Stanley in May 1965. The reception was held in the Sancta Maria hotel and showband singing star Sean Dunphy was among the guests. He was known for performing in a suit and tie, when showbands were changing to theme costumes, and he was equally well-dressed in this photograph taken with fans from the Sancta Maria staff, including (back right) Kathleen Devins (*née* Mannion). (*Photograph kindly made available by the Mannion family.*)

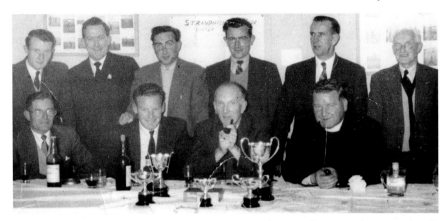

Prizegiving at Strandhill Golf Club, with long-time members Frank Wynne (front centre) and Strandhill priest Fr Thomas Moran (right). Back row, first left is Val Harte. Fr Moran was club Captain in 1948 and 1949, and President from 1956 to 1965. This photograph was probably taken some time in the 1950s. The golf links opened in August 1931. The clubhouse was built in a field where there was formerly a house called Bustard's Lodge. (*Photograph kindly made available by Strandhill Golf Club.*)

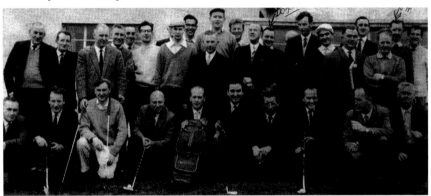

Members of Strandhill Golf Club pictured outside the clubhouse before Bill Cannon's Captain's Prize, 1962, with Val Harte (front row, second left) and fourth from right his brother Don. Middle row, second right is Stephen Scanlon, and third, Tony Mannion. Back row, second right is Joe Kelly and sixth right is Donald Bree. The old clubhouse is in the background. (*Photograph kindly made available by Donald and Joan Bree.*)

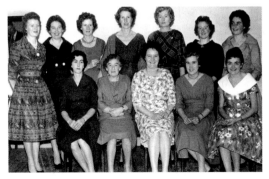

Captain's Day 1960 in Strandhill Golf Club, with Lady Captain J. Cleary and club members. At front row, second left is Peg Kelly, who was teacher at Strandhill national school. (*Photograph kindly made available by Strandhill Golf Club.*)

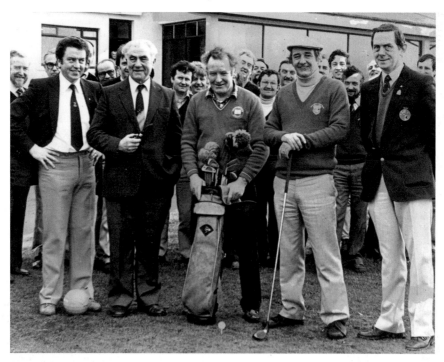

The 1983 Captain's drive-in at Strandhill Golf Club, with Captain Liam Kilcawley (second right) and (from left) Jim Raftery, Vice-Captain, Stephen Scanlon, Val Harte, President of Strandhill Golf Club, and Fred Perry, President of the Golfing Union of Ireland. (*Photograph kindly made available by Strandhill Golf Club.*)

OPPOSITE BELOW: This Gulf Stream IV, a very fast aircraft, visited Sligo Airport in the early 2000s on a private flight.

ABOVE: Captain Arthur Wignall (right) was a former RAF and Aer Lingus pilot, and a leading acrobatic pilot in the 1980s. He was the first flyer to be awarded Sligo Aero Club Hall of Fame, which he received in Strandhill Airport. Tragically, he was killed the following day, 1 April 1984, while flying practice manoeuvres over Strandhill. He is seen here in his Pitts S2A display plane at Strandhill Airport. His award is on display in the airport. (*Photograph kindly made available by Sligo Regional Airport, Strandhill.*)

Mother Teresa of Calcutta, at the age of eighty-five, disembarking from her chartered plane at Strandhill Airport in June 1996. She had travelled to Sligo to visit nuns of her order and to receive the Freedom of the Borough of Sligo. She was declared a saint of the Roman Catholic Church in September 2016. (*Photograph kindly made available by Sligo Regional Airport, Strandhill.*)

A severe storm in 1988 tore off most of the hangar roof and damaged this Piper J-3C-65 Cub at Strandhill Airport. (*Photograph kindly made available by Sligo Regional Airport, Strandhill.*)

Strandhill residents were treated to the sight of these colourful hot air balloons floating over the face of Knocknarea during the Irish Balloon Festival in 1995. The balloons prepared for take-off at Strandhill Airport. (*Photograph kindly made available by Sligo Regional Airport, Strandhill.*)

In 2002, Euroceltic Airways was awarded operation of the Sligo to Dublin service. They operated on this route from July 2002 to January 2003, when the airline ceased trading. In November 2002, thirty-six passengers and four crew members had a lucky escape when their Fokker 27 plane skidded and overshot the runway when attempting to land in gusty conditions. Though the nose ended semi-submerged in the sea, the tide and sea level were low at the time. (*Photograph kindly made available by Andy Higgins.*)

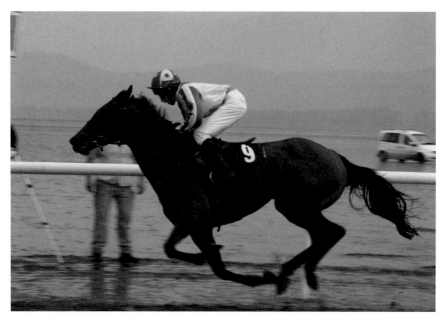

Horse racing has taken place on Culleenamore beach since at least 1821. The races lapsed and were revived many times since then, most recently in the early 2000s, when this horse was photographed galloping through the incoming waves. (*Photograph kindly made available by Hugh MacConville.*)

Young jockeys prepare for their race, helped by family members, at Culleenamore beach horse races in the early 2000s. (*Photograph kindly made available by Hugh MacConville.*)

One race finished and more to come at Culleenamore races. (*Photograph kindly made available by Hugh MacConville*)

Watching the Culleenamore races from the sand dunes in the early 1950s are (left to right): Michael Mannion, Denis Mannion, Donald Bree and Paddy Duggan. The man drinking from the bottle is Belfast man Larry Wilson, who worked as a butler in Glen Lodge. The heavy overcoats they are wearing suggest that the weather was not very good. (*Photograph kindly made available by the Mannion family.*)

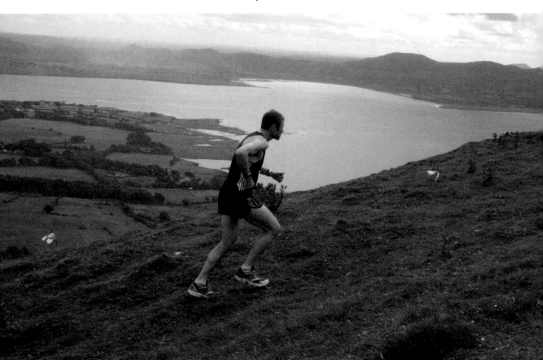

Against the background of Ballisodare Bay, this competitor runs towards the summit of Knocknarea during the annual Strandhill Warriors Run in the early 2000s. The 15k running and walking event starts at the cannon at the seafront and goes to Maeve's Cairn (the reputed grave of Queen Maeve of Connacht) on the summit and back again. Originally associated with the Sligo triathlon, the first race was run on 14 June 1985 and had 160 runners. Now, about 1,000 people take part. (*Photograph kindly made available by Hugh MacConville.*)

Young 'warriors' from Strandhill, who helped steward the Warriors Run and added to the colour, seen here in the early 2000s. They are Stanley O'Grady (left) and Kevin Carty. (*Photograph kindly made available by Hugh MacConville.*)

All the fun of the fair at an early Warriors Run in the mid-1980s. (*Photograph kindly made available by Hugh MacConville.*)

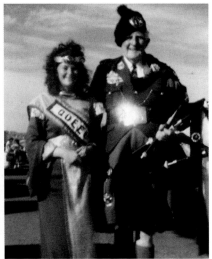

LEFT: Sligo businessman Kieran Horan driving his horse-drawn carriage was a regular sight at the early Warriors Run events. (*Photograph kindly made available by Hugh MacConville.*)

RIGHT: The Queen Maeve beauty competition for young women used to be held every year as part of the early Warriors Run festival, and the winner would drive around the seafront in her chariot before and after the race. This is an early Queen Maeve, Sheila Gray, with bagpipe player Lar O'Dowd. (*Photograph kindly made available by Ita McMorrow Leyden.*)

Ciaran Foley, Larass, highlighted a campaign to protect Dorran's Strand from a proposed extension to the airport runway when he ran the Warriors Run in 2007. On the left is Deirdre Foley. (*Photograph kindly made available by Hugh MacConville.*)

A proposal to extend the runway at Strandhill Airport out over Sligo Bay near Dorran's Strand caused concern over its potential effects on the environment and access to Coney Island. Public meetings and protests were held. This poster advertises a protest walk across the sands to Coney Island in November 2007.

Public objectors to the extension of Sligo Airport runway over Dorran's Strand walk down The Line towards the strand on their way to a public meeting on Coney Island in 2007.

10.
Changing Times

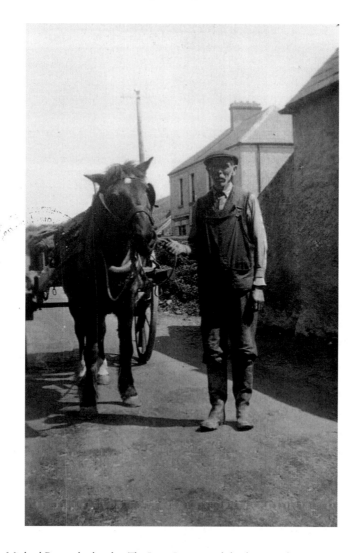

Farmer Michael Bree, who lived at The Line, Larass, with his horse and cart, pictured in the early twentieth century beside the present-day Bree's pub. The Brees' two-storey house, near the shore end of The Line, was replaced by a modern house in 2019. (*Photograph kindly made available by Andy Higgins.*)

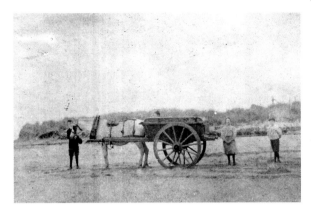

A horse and cart belonging to the Nuttall family at the Sandy Field shore at the southern end of Culleenamore beach. They may have gone to collect seaweed for fertiliser. Bob Murrow and Denis Mannion both recalled going there with pony and cart to collect seaweed, in Bob Murrow's case *feamain* or bubble wrack for the family seaweed baths, in the 1930s and 1940s. Seaweed for fertiliser grew further out. (*Photograph part of Nuttall collection and kindly made available by the Mannion family.*)

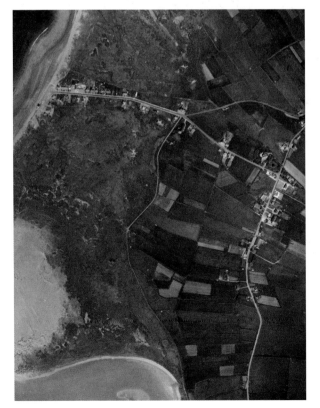

Between the 1930s and 1970s, the Irish Air Corps carried out a number of aerial surveys of coastal areas for the Department of Defence. This is one of the photographs they took of Strandhill. It looks down on Carrowbunnaun, with the Top Road (R292) seen as a white line on the right. The line at the top of the image is Buenos Ayres Drive, joined by the Burma Road, going down to the seashore. The Burma Road was extended to join Buenos Ayres Drive in 1945, so the photograph must have been taken after that. Much of the land is open dunes or fields and there are relatively few buildings. The Murrow family home and its circular walled garden is visible middle right at the junction. (*Photograph kindly made available by Irish Military Archives, Cathal Brugha Barracks, Dublin.*)

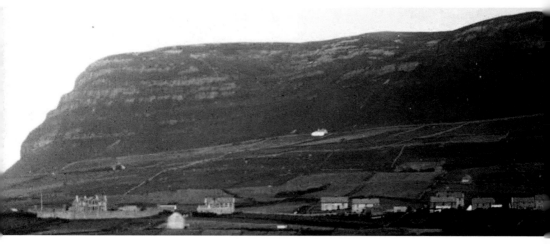

Nestling below Knocknarea, Buenos Ayres House, the Atlantic Hotel and several hotels and houses on the Top Road can be seen. Missing is the conifer forestry on the mountain slopes, which had not yet been planted. The white building below the cliffs was a house used by a herd employed by the Walker family at Rathcarrick, who owned 1,500 acres in the vicinity in the mid-nineteenth century. It was later occupied by the Ward family, after Patrick Ward was evicted by Benjamin Murrow from his house near the present Venue pub. (*Photograph part of the Laurence Collection and kindly made available by Stefan Bergh.*)

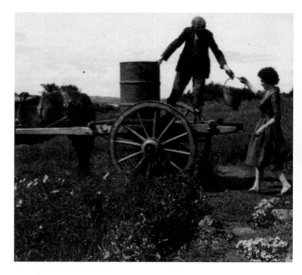

LEFT: The names of the best oarsmen in Strandhill are recorded by James Howley in this Schools Collection essay by Michael Molony, who calls them 'Local Heroes'. The rowing seemed to have been a competitive sport rather than for fishing. (The Schools' Collection, Volume 0159, p.14, 1937–1938).

RIGHT: Bernard Mannion, of the Mannion family of Carnadough, getting ready to collect water from the pump in Carrowbunnaun, as his daughter Kathleen hands him the bucket. The water was collected in the barrel. Drinking water was taken from a spring well in Carnadough, which is still in use. (*Photograph kindly made available by the Mannion family.*)

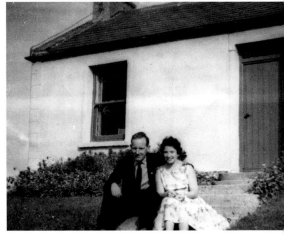

The newly built Hillcrest Park estate on Buenos Ayres Drive in 1982. (*Photograph kindly made available by Hugh MacConville.*)

Joan Bree in 1959 with Sean Kelly, son of Garda Sgt Kelly who retired to this house on the Golf Links road with his family. Strandhill had its own RIC (later Garda) barracks on the Top Road, which later became the home of the Cosgrove family. Among the gardaí who were stationed there were Sgt Mullane, Gda McMahon, Gda Maloney, who was also the school in-spector, and Gda Carr. Garda Maloney lived near the old school and Gda Carr lived in Larass. This small area between the modern national school and the presbytery was called Lough Hoo. There was a spring well in Lough Hoo, behind the house on the Golf Links road that is opposite St Patrick's church. (*Information and photograph kindly made available by Donald and Joan Bree.*)

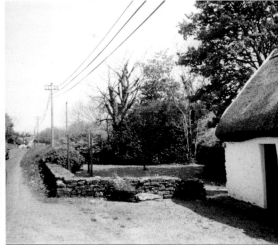

LEFT: The triangle at the northern entrance to Strandhill was first landscaped by members of the Strandhill Guild of the ICA in the 1990s. (*Photograph kindly made available by Strandhill Guild, ICA.*) RIGHT: The narrow former main road from Strandhill to Sligo at Dolly's Cottage in 1999. (*Photograph kindly made available by Strandhill Guild, ICA.*)

Work is underway on the new main road, seen from the back of Dolly's Cottage about 2001. In a field beside the new stretch of road was the small settlement called Ballyglass, which is shown on old maps. Older people recall at least three small houses there, called Brown's, Black's and Moore's, and a well. (*Information and photograph kindly made available by Strandhill Guild, ICA.*)

Sligo Airport Company was formed in 1973, with a plan for developing a private grass airstrip at Strandhill. This photograph shows the ground being seeded for the grass aero club runway. The tractor to the left was provided by Joe Hession, and to the right by Des Miller, both Aero Club members. Joe Corcoran, manager of Sligo Regional Airport, operated the hopper. All the work was done voluntarily by members of the Aero Club. (*Photograph kindly made available by Sligo Regional Airport, Strandhill.*)

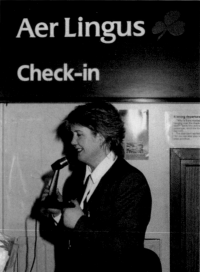

LEFT: Sligo Regional Airport manager Joe Corcoran in the early 1990s. (*Photograph kindly made available by Sligo Regional Airport, Strandhill.*)
RIGHT: Airport ground crew member Mary Howley making a flight announcement. (*Photograph kindly made available by Sligo Regional Airport, Strandhill.*)

The new access road to the airport was built opposite the Baymount Hotel, where apartments are now located, in 1981. There is no forestry to the left of the road, where mature trees now grow, so the forestry either had not been planted or was very young.

The Strandhill Notes section of *The Sligo Champion* in 1981 reported progress on developing a hard runway and road access at the site of the planned Sligo Regional Airport. The runway and road were completed in July 1981. In 1981, a development committee had been set up to establish a Sligo Regional Airport at Strandhill to improve transport access to the north-west. (*Photograph kindly made available by Sligo Regional Airport, Strandhill.*)

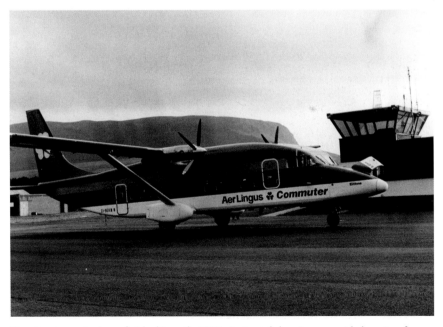

The airport terminal was finished in early 1983. Avair, and then Iona, provided services from Dublin to Sligo until 1988, Aer Lingus from 1988 to 1998, and Aer Arann between 1998 and 2012. An Aer Lingus commuter service plane Short 360-100 is waiting on the tarmac. (*Photograph kindly made available by Sligo Regional Airport, Strandhill.*)

Sligo Regional Airport Board and local officials mark the first Aer Lingus flight from Dublin into Strandhill in 1988. In the picture are (left to right): county councillor Matt Lyons, Paddy Gillen of Aer Lingus, Steward Greer, board member, Peter Henry, board member; Seamus Finn (obscured), editor *The Sligo Champion*; Alderman Sean McManus; Paul Byrne, Sligo County Manager; county councillor Tony McLoughlin; Ray Wilson, CEO Aer Lingus commuter section; Dan O'Neill, manager Sligo Regional Tourism; Padraig Ferguson, board member; county councillor Michael 'Mixer' Carty; Joe Hession, member of the board and of Sligo Aero Club; John Martyn, instructor and Sligo Aero Club member, and Joe Corcoran, airport manager. (*Photograph kindly made available by Sligo Regional Airport, Strandhill.*)

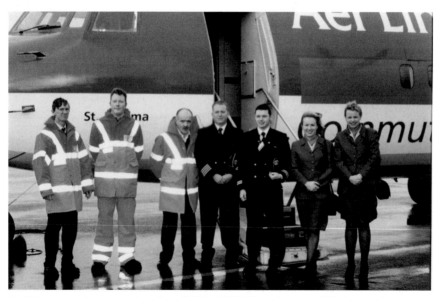

Aer Lingus ceased its service into Strandhill in 1998. Here, the crew of the last Aer Lingus flight prepares to fly out for the last time. (*Photograph kindly made available by Sligo Regional Airport, Strandhill.*)

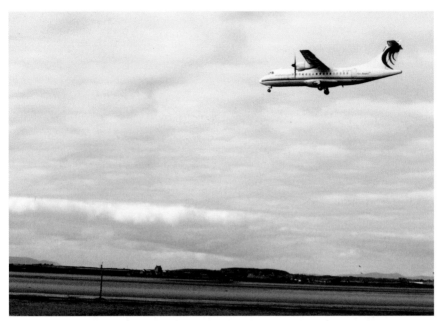

Aer Arann took over from the Aer Lingus service in 1998. An Aer Arann plane approaches the runway with the forestry in the background. (*Photograph kindly made available by Sligo Regional Airport, Strandhill.*)

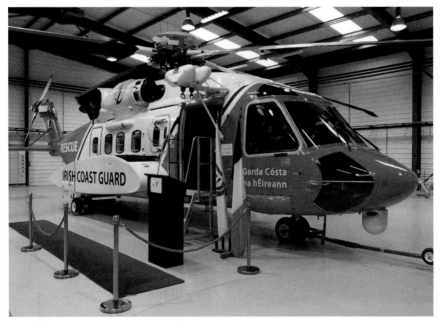

Although the last Aer Arann flight flew to Dublin in 2011, Sligo Airport remained the base for the Irish Coastguard air sea rescue service in the north-west. Initially it used a Sikorsky S-61 helicopter and in 2013 the helicopter was upgraded to an S-92, seen in this photograph, which had a greater range. (*Photograph kindly made available by Sligo Regional Airport, Strandhill.*)

Benjamin Murrow's Buenos Ayres House was bought around the 1970s and replaced by a single-storey bungalow. This was sold in the mid-2000s and lay derelict for some years, falling into decay. It was demolished in 2018.

LEFT: Although the house and gardens fell into decay, the gates into the walled garden still remained in 2015. RIGHT: The castellated wall that surrounded the Murrow family home also remained in 2015, though the surrounding trees are overgrown.

The remains of the herd's house on Knocknarea that became the home of the Ward family after they were evicted from their house on the Top Road. It stands beside the Queen Maeve's Trail to the summit. (*Photograph kindly made available by Stefan Bergh.*)

Thady Higgins' house at the bottom of the Burma Road was in ruins in 2006. It was demolished about ten years later. (*Photograph kindly made available by Hugh MacConville.*)

In January 1968, a group of surfing enthusiasts from the Surf Club of Ireland made a 'Surfari' to Strandhill, where, as current Irish champion Kevin Cavey told *The Sligo Champion* on 12 January, 'interest is very keen'. Dave Kenny, one of the group, is seen surfing Strandhill's waves against a background of Dunmore and the Ox Mountains. (*Photograph kindly made available by Dr John O'Donnell.*)

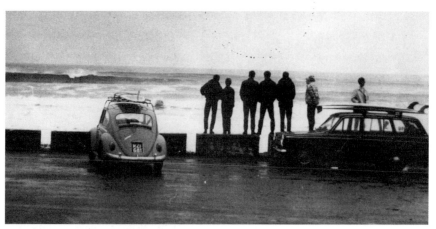

Some of the 1968 Surfari group inspect the waves at Strandhill (left to right): Ken McCabe, Helen McCabe, Dave Kenny, Johnny Lee, Harry Evans, unknown, and Ann Kelly. (*Photograph kindly made available by Dr John O'Donnell.*)

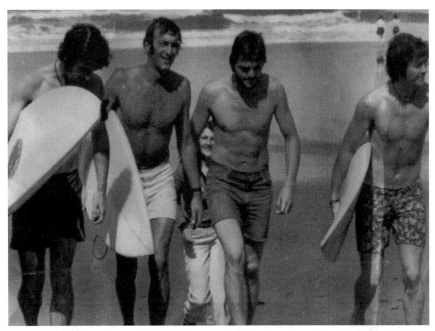

RIGHT: In 1972, this group of local surfers were photographed coming out of the waves at Strandhill (left to right): Ray Westby, Stan Burns, Lotch (Padraig) Lynch and Tom Hickey. The first person to surf in Strandhill was Willie Parke in 1965, and Sean Mannion collected his new surfboard for him from Lenehan's hardware shop in Capel Street, Dublin. (*Photograph kindly made available by Stan Burns.*)

Time moves on, and early surfers become teachers to a new generation. Tom Hickey set up Perfect Day Surf School in 1998. It occupied various premises over the years, including at the rear of this building on the seafront, where it announced its presence in dramatic surfer fashion.

Appendix: Map Guide

Townlands and Features of Strandhill over the Centuries

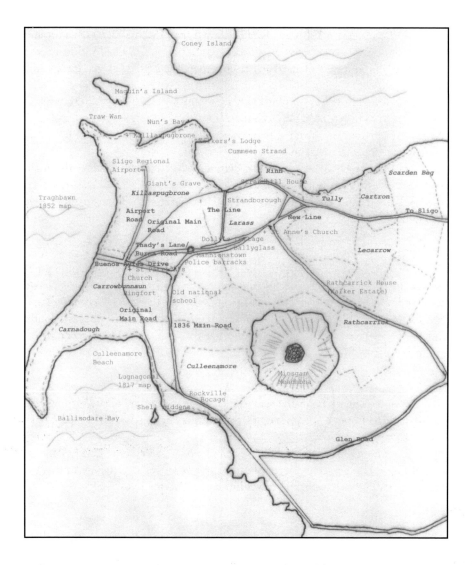

The information in this map reflects history and changes in Strandhill from the early nineteenth century to the present day.

Roads

A single line marks the route of the centuries-old main road from Ballisodare to Sligo. This travelled along the northern side of Ballisodare Bay to the junction of

Culleenamore and Carnadough townlands. where it went down along the shore then proceeded over the sand dunes of Carnadough, Carrowbunnaun and Killaspugbrone, before moving northeast into Rinn. It emerged from Rinn at Tully and continued to Sligo.

Modern roads are shown by double lines

In 1836, the present main road (R292), shown by a double line, was built and took a more easterly, inland route to the old road. The road originally went only as far as St Anne's church, and another stretch, called The New Line, was built in the 1840s to join with the old road coming up from Rinn.

The 1836 road used to go past Dolly's Cottage until the early 2000s, when it was realigned to the rear of Dolly's Cottage between the roundabout and St Anne's church. At different times, small roads were opened to connect the 1836 road to the shore at Cummeen Strand, called The Line, and to Rinn.

Buenos Ayres Drive was built by Benjamin Murrow to connect the main road at Carrowbunnaun to the seashore, which he developed as a seaside resort. Thady's Lane, once a farm path, was extended to join with Buenos Ayres Drive in 1945.

Townland features

Townland names are in italic print. The dotted lines show the location and boundaries of the various townlands referred to in this book. Townlands in the core area of Strandhill are Carrowbunnaun, Killaspugbrone and Larass. Other townlands in the wider Strandhill area include Culleenamore and Carnadough to the south, Rinn, Tully, Cartron and Scarden Beg to the north, and Rathcarrick and Lecarrow to the north-east.

Rinn

Strandhill House sits on the seashore at Rinn, where the old road originally ran. It was the home of the Meredith family and estate, which included Coney Island, between 1788 and 1964.

Strandborough is shown on the 1817 William Larkin map of County Sligo as a cluster of buildings at Cummeen Strand, Rinn. It is probably the location of the original Strandhill village before it was buried by blowing sand.

Killaspugbrone

Killaspugbrone early Christian church site and graveyard sit on the northern shore of Killaspugbrone townland.

Nuns' Bay is the sandy beach to the right of Killaspugbrone church. Traw Wan ('Trá Bán) or 'White Strand' is the sandy area to the left of Killaspugbrone graveyard.

Traghbawn, or 'White Strand', is also the name given to the main beach of Strandhill in the 1852 survey of Sligo Bay by Captain G.A. Bedford.

The Giant's Grave lies to the east of the Airport Road in Killaspugbrone.

The former RIC, later Garda, barracks was located to the north of the junction of Buenos Ayres Drive and the main road, and is now a private house.

Larass

Larass townland stretches from the shore beside Rinn up to the side of Knocknarea. Within Larass, there are areas called Mannionstown and Foleystown, named after local families, and The Bridge, which is beside a small stream called The Brook, which runs under the main road and down The Line to the shore at Rinn.

Dolly's Cottage is in Larass townland, just off the realigned route of the main Strandhill to Sligo road.

The site of Ballyglass is on the mountain side of the realigned main road, roughly opposite Dolly's Cottage and the petrol station.

The Walker family lived at Rathcarrick House. The family built up a large estate in the nineteenth century and also acted as land agent for the Palmerstown, Ormsby and De Butt estates. Roger Chambers Walker was interested in archaeology and antiquities. He searched many of the Neolithic tombs in Coolera and collected artefacts, though he did not keep a proper record of his discoveries. The last male Walker, John Walter Walker, died in 1950 and the Land Commission divided the land.

Carrowbunnaun

Buenos Ayres Drive and Strandhill seafront are in Carrowbunnaun. Thady's Lane, now the Burma Road, stretches from the main road at the first roundabout to the mid-point of Buenos Ayres Drive, which connects the main road to the seashore.

The old school is now a private house on an elevated site just south of the junction of Buenos Ayres Drive and the main road.

The ringfort, just one of many in the wider area of Strandhilll and Knocknarea, is located between St Patrick's church and the modern national school on the route of the old Ballisodare to Sligo road.

Carnadough

Carnadough stretches from Strandhill beach and Portcurry Point, at the tip of Culleenamore beach, to Knocknarea mountain.

Culleenamore

Freeman Aeneas Nuttall ran his successful market garden at Culleenamore, and the houses called Rockville and Bocage are located in the townland.

Shell middens can be found in grassy banks beside the seashore at Culleenamore.